IMAGES
of Rail

TORONTO'S RAILWAY
HERITAGE

RAILWAYS OF TORONTO
Names and opening dates

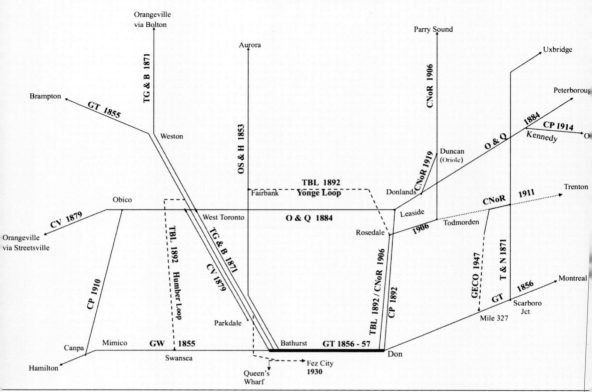

The railway companies referred to in the text are schematically illustrated in this map along with the year that operations began in Toronto. By 1923, all had become part of either the Canadian National or the Canadian Pacific Railway. Canadian National constituents include Ontario, Simcoe & Huron Railway (OS&H, renamed Northern Railway of Canada in 1858), Grand Trunk Railway (GT), Great Western Railway (GW), Toronto & Nipissing Railway (T&N), Toronto Belt Line Railway (TBL), and Canadian Northern Railway (CNoR). Canadian Pacific constituents include Toronto, Grey & Bruce Railway (TG&B), Credit Valley Railway (CV), and Ontario & Quebec Railway (O&Q).

On the cover: The culmination of railway development and influence in Toronto is illustrated in this 1930 image that was photographed shortly after the completion of the magnificent Union Station. Four immaculate passenger locomotives pose at the east end of the train shed while the Canadian Pacific Railway's new Royal York Hotel rises in the background, the largest hotel in Canada and the tallest building in Toronto. (Ontario Archives, 10002051.)

IMAGES
of Rail

TORONTO'S RAILWAY HERITAGE

Derek Boles

ARCADIA
PUBLISHING

Published by Arcadia Publishing
Charleston, South Carolina

Printed in the United States of America

Library of Congress Control Number: 2009925477

For all general information contact Arcadia Publishing at:
Telephone 843-853-2070
Fax 843-853-0044
E-mail sales@arcadiapublishing.com
For customer service and orders:
Toll-Free 1-888-313-2665

Visit us on the Internet at www.arcadiapublishing.com

*To my parents, Al and Joy Boles,
who helped nurture my interest in trains as long ago
as I can remember and have been supportive ever since.*

CONTENTS

ACKNOWLEDGEMENTS

Glenn Garwood of City of Toronto Culture made it possible for me to access the wonderful photographic collection in the Toronto Archives and has been the driving force behind the Toronto Railway Heritage Centre.

Toronto Railway Historical Association President Orin Krivel has been a good friend and an inspiration, and without his prodigious efforts there would not be a Toronto Railway Heritage Centre.

The late Omer Lavallee, one of Canada's most distinguished railway historians, published the first article I ever wrote on railway history when I was 17 years old.

Mike Filey recommended me to Arcadia and has educated and entertained Torontonians about Toronto history since I bought his first book back in 1970.

John Riddell was the first to uncover the vast trove of photographs illustrating Toronto's railways that were available in our public archives and wrote two books about it.

My colleagues on the Toronto Railway Historical Association Board include Michael Guy, Andrew Jeanes, Ed Levy, Russ Milland, Phil Spencer, Jason Shron, and Dan Garcia.

Image sources are identified as follows: City of Toronto Archives (CTA), Toronto Public Library (TPL), Ontario Archives (OA), National Archives of Canada (NAC), Canada Science & Technology Museum (CSTM). Images not otherwise credited are from the collection of the author.

INTRODUCTION

On October 15, 1851, Toronto's most prominent citizens gathered in a vacant lot on the south side of Front Street between Simcoe and John streets. Among those attending was the Mayor of Toronto and the Governor General of Canada, the Earl of Elgin. The occasion for this auspicious gathering was the turning of the sod for the Ontario, Simcoe & Huron Railroad, the first steam railway to operate in Ontario. Torontonians eagerly anticipated the coming of the railways, and the sod turning was an occasion for festivities that included a grand parade through the streets and a splendid ball that night at St. Lawrence Hall.

The first trains in Canada had commenced operations near Montreal in 1836, so the railway era began relatively late in Ontario. Before the railway, Canada depended on navigable water routes for transportation, but these were frozen for as much as five months of the year. Overland travel by stagecoach was expensive and uncomfortable, even for the elite few who could afford it. Transported goods were frequently damaged on journeys over rough roads and trails.

By 1850, the construction of new railways in Canada was seen as the key to economic survival. There were already over 9000 miles of track in the United States; in Canada there were less than 60. One impediment to further railway development was a lack of private investment capital, a situation that improved when the government introduced legislation that provided financial incentives for the business community to invest in the building of new railways.

On May 16, 1853, the first passenger train steamed out of Toronto from a wooden depot that was located close to the eastern entrance of today's Union Station. The Ontario, Simcoe & Huron, like most of Canada's first railways, was a portage route between the two Great Lakes that made up its name. It provided an overland bridge connection along the ancient Toronto Passage trading route, saving hundreds of miles of steamship travel. The first era of Canadian railway expansion had begun, and within 10 years there were over 2000 miles of track.

At the beginning of the railway era, Toronto was a modest commercial centre that had only become an incorporated city two decades earlier. Montreal was a larger and older municipality, and it dominated economic activity in Canada. Toronto wanted to stimulate its economic influence by increasing commercial activity with the United States, an initiative that had begun even before the railway era with the opening of the Erie Canal in 1825. The railway corridors through the city evolved as a trade axis between the midwestern United States and the Eastern Seaboard.

The railways had a profound impact on the economic fortunes of Toronto, and this led to unprecedented economic growth and prosperity. Toronto's economy evolved from a government and trading centre into a hub of manufacturing. Vast quantities of raw materials could be

transported into the city, and the resulting manufactured goods could then be expeditiously shipped out to the rest of Canada. Toronto's excellent harbour also enabled the city to become an important transshipment point between rail and water transportation.

In 1855 the Great Western Railway opened a new suspension bridge over the Niagara River, providing Toronto with a direct rail connection to New York five years before Montreal enjoyed the same advantage. In 1856 the Grand Trunk Railway of Canada completed its main line between Montreal and Toronto and a journey that previously took several days could be completed in 14 hours, a cause for much celebration in both cities.

The railway also provided Torontonians with more visceral sensations. They experienced the thrill of travelling through the countryside at 30 miles an hour, faster than most of them had ever moved before in their lives. The coach window also served as a theatrical proscenium, behind which passengers could enjoy a rapidly changing visual panorama, an experience not replicated until 40 years later with the invention of the motion picture.

In the first years of the railway era, each railway company wanted to build its own engine terminals, stations, and yards. The narrow shelf of land between Front Street and the top of the embankment leading down to the harbour was not wide enough for any additional railway tracks. Further expansion of Toronto's rail network required the acquisition of new land that was created by filling in Lake Ontario.

The railways were forced to share the limited real estate available, resulting in Canada's first Union Station, built by the Grand Trunk in 1858 on landfill southwest of Front and York streets. A union station is a facility shared by two or more railways and for a time the Grand Trunk shared this structure with the Great Western and the Ontario, Simcoe & Huron, by now renamed the Northern Railway of Canada. However, the other railways were not happy with this arrangement and they continued to build their own facilities along Toronto's waterfront. A faltering economy in the late 1850s ended Toronto's first era of railway expansion.

As with all sweeping technological change, the railway proved to be the "machine in the garden," a mixed blessing for the people of Toronto. The railways were built by private companies that were the mightiest corporations of their day. Their sole reason for existence was to make a profit for their shareholders, and that goal often conflicted with what the public perceived as being in the best interests of their communities. Nowhere in Canada was this conflict more apparent than in Toronto where the relationships between the railways and the city were frequently acrimonious.

The tracks physically scarred the city and cut Torontonians off from Lake Ontario, the municipality's primary recreational and scenic asset. The railway companies hogged the best real estate in town, swallowing up vast tracts of prime waterfront land for stations, roadbed, tracks, buildings, yards, and servicing facilities. When the land did not already exist, the railways and the harbour authorities created new land, dumping massive quantities of landfill into Lake Ontario and further distancing Torontonians from their lakeshore.

In 1867 the Dominion of Canada was created through a Confederation of the British colonies and Toronto was designated the capital of the new province of Ontario, thus ensuring its stature as the most important city in the province. In 1873 the Grand Trunk replaced the first Union Station with a new facility that was larger and more opulent than any other station in Canada, a source of great pride for Torontonians who often felt overshadowed by Montreal.

The railway system then entered a second era of expansion as more new companies laid tracks into the city, including the Toronto & Nipissing; the Toronto, Grey & Bruce; and the Credit Valley Railways. By far the most formidable of the new companies was the Canadian Pacific Railway (CPR), incorporated in 1881 to build a transcontinental railway connecting Central Canada with British Columbia. Toronto was located 250 miles south of this main line, but the CPR rapidly acquired an Ontario rail network that directly competed with the Grand Trunk.

By 1888 both railways had acquired all the smaller companies operating into Toronto, either by consolidation or outright takeover. Many of the early Toronto railways had been local business ventures, built and financed by Ontario businessmen. The Grand Trunk and Canadian Pacific

maintained their corporate headquarters and major locomotive and car shops in Montreal. This fact was resented by Torontonians who viewed the railways as absentee landlords unwilling to respond to local needs and priorities.

By 1880 the Grand Trunk extended 1100 miles from Portland, Maine, to Chicago, Illinois, the longest railway in the world under one management. In 1885 the Canadian Pacific Railway was completed between Montreal and the Pacific Ocean, a distance of 3000 miles.

Toronto Union Station was rebuilt and expanded in the 1890s, but by the dawn of the 20th century the facility was hopelessly inadequate for the 120 passenger trains entering the expanding city on a daily basis. An 1899 issue of *Railway and Shipping World* stated that "the general consensus of opinion is that the Toronto Union is one of the most inconvenient stations in [North] America, expensive to run and unsatisfactory in very many other respects."

In 1904 two events occurred that would have a profound influence on railway development in Toronto. In April what became known as the Great Toronto Fire cleared a large swath of land for a new Union Station along Front Street. On November 17 a collision between a Toronto Railway Company wooden streetcar and a Grand Trunk freight train at the level crossing on Queen Street near DeGrassi Street killed 3 passengers and injured 17 more. There were now as many as 16 tracks hindering public access to the waterfront, and several people, including many children, were killed or injured every year while attempting to cross the busy rail corridor. The City of Toronto was determined to resolve both problems, although it would be another quarter century before a solution was at hand.

In 1906 a new railway company, the Canadian Northern, further added to the overcrowding and provided fresh competition with the Grand Trunk/Canadian Pacific duopoly. Two ambitious Torontonians, William Mackenzie and Donald Mann, created the Canadian Northern, the only transcontinental railway to have its national headquarters in Toronto.

Railway influence in Toronto extended far beyond geography. In the early 20th century, it was estimated that one out of every five private-enterprise employees in the city were either employed by the railways or worked for businesses that were directly dependent on them.

Prior to the railway era, tourism was a privilege only enjoyed by the wealthy. The railways invented tourism for the masses and gave Torontonians a sense of restlessness and mobility. For the first time, people began to travel for pleasure. Previously isolated and distant, lake districts like the Muskokas and the Kawarthas became weekend retreats for well-heeled city folk. Torontonians seeking to escape the uptight waspishness of "Toronto, the Good" in search of more sophistication and glamour could now travel to Montreal or New York City in a day.

The huge wave of European immigrants that came to Canada in the first half of the 20th century was carried by ocean liner to the eastern port cities of Halifax, Quebec City, or Montreal. Then they were herded into railway colonist cars, the land equivalent of a ship's steerage class, for delivery to their final destination. Over the years, hundreds of thousands of immigrants stayed in Toronto and the city's population exploded. The railways, even more than the Canadian Government, were directly responsible for most of this immigration and maintained hundreds of agents in Europe whose job it was to entice potential migrants to Canada.

By 1913 the railways and the city of Toronto agreed to build a new Union Station and find a solution to the grade crossing problem. However, due to railway intransigence and a lack of funding, construction on the new station did not begin until 1915. The Canadian Pacific Railway claimed to be frustrated with the delays, even though its own legal machinations were largely responsible. In 1916 Canadian Pacific opened North Toronto Station, a magnificent Beaux-Arts structure that was intended to be shared with the Canadian Northern Railway. Canadian Pacific also built a new office skyscraper at King and Yonge streets that was briefly the tallest building in the city.

Unfortunately, by 1914 and the start of World War I two of Toronto's most important railways were in financial trouble. The Canadian Northern was insolvent and heavily indebted to the Toronto-based Bank of Commerce. The Grand Trunk was also in financial peril, mainly due to an overly ambitious expansion to the Pacific Coast. In 1912 the president of the Grand Trunk

had gone down with the *Titanic* and the fortunes of the company unraveled shortly thereafter. At the end of the war, the federal government nationalized the Canadian Northern and Grand Trunk and consolidated them into the new Canadian National Railway. Canadian National headquarters were briefly located in Toronto until 1923, when they were relocated to Montreal where they remain today.

The war also delayed the construction of the new Union Station, a process that dragged out over five years due to a shortage of financing, building materials, and workmen. When the head house was finally completed in 1920, Union Station was the largest and most magnificent railway terminal ever built in Canada, Toronto's finest example of monumental Beaux-Arts architecture and a showcase for railway supremacy and civic pride.

However, the station sat empty for the next several years while the railways, the city, and the newly formed Harbour Commission argued about what to do about the tracks along the waterfront. All the stakeholders agreed that the tracks should be elevated with roads and sidewalks passing underneath. They still could not agree on how much it should cost and who should pay for it until 1924, when several compromises resulted in the construction of the waterfront grade separation. The present Union Station finally opened in 1927, although the train shed and the viaduct were not completed until 1930, 26 years after the conflagration that precipitated its construction.

The enormous footprint of the railways in Toronto was most evident in the Railway Lands located south of Front Street between Yonge and Bathurst streets. This colossal railway complex included Union Station, its train shed, and miles of approach tracks, locomotive servicing facilities for both Canadian National and Canadian Pacific railways, huge yards capable of storing several hundred 85-foot-long passenger cars, freight yards, industrial sidings, interlocking towers, bridges, warehouses, commissaries, express terminals, and a host of other facilities. North of Front Street, the entire blocks bounded by John, King, and Simcoe streets were occupied by freight and express yards. In 1929 Canadian Pacific opened the Royal York, the largest hotel in Canada. A vast maze of freight sidings was also built throughout the industrial sections of Toronto to service the manufacturing sector that dominated the city.

Despite the railways vastly increasing their Toronto real estate holdings during the 1920s, passenger train service actually began to shrink as more people acquired automobiles and branch line service into the city was reduced from twice a day to daily. The Depression resulted in significant job layoffs and reductions in service, a process only temporarily halted by World War II. From the 1950s on there was a steady decline in intercity passenger rail service, a reduction only halted in the 1990s, when train travel became competitive with congested highways and increasingly unreliable airlines.

Meanwhile, the railways disposed of their downtown property, much of it grimy industrial land that had evolved into some of the most valuable real estate in Canada. The vast Railway Lands were sold off for commercial, recreational, and residential redevelopment, including the CN Tower, Skydome, the Air Canada Centre, the Metro Toronto Convention Centre, and Thomson Hall. Outside the Union Station Rail Corridor, only Canadian Pacific's John Street roundhouse, now the Toronto Railway Heritage Centre, survives as the last remnant of these servicing facilities.

With the establishment of GO Transit in 1967, Union Station began to evolve from primarily an intercity rail terminal to a commuter train hub. Today 160 000 commuters stream through the station every weekday, making it the busiest location anywhere in Canada.

As Toronto's manufacturing base began to flee the city in the 1970s for cheaper overseas production, the infrastructure of downtown freight yards and sidings also disappeared, a process that was essentially complete by the dawn of the 21st century. Today only a handful of industries in the old city of Toronto are still served by rail.

This book is a photographic record of the first 75 years of the railway era, when the Grand Trunk, Canadian Pacific, and Canadian National railways held dominion over the city of Toronto.

One

THE RAILWAY
ERA BEGINS

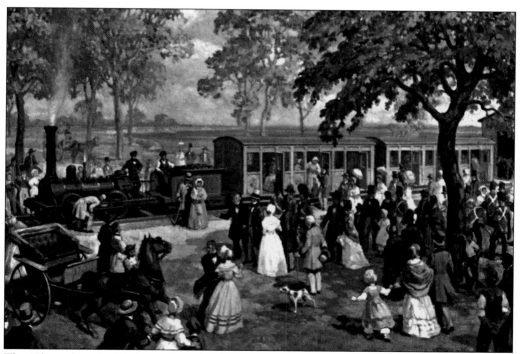

The Champlain & St. Lawrence, the first steam railway in Canada, began operations near Montreal in 1836. Around the same time, Toronto business leaders agitated for their own railway but a recession and the Upper Canada Rebellion delayed the project for several years. In 1849 a Toronto entrepreneur named Frederick C. Capreol proposed a lottery to finance a new railway, an idea not warmly embraced by Toronto's Victorian establishment.

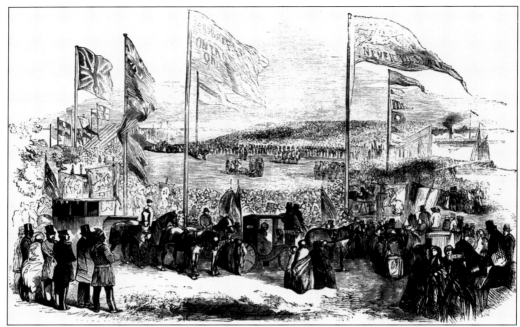

The railway era in Toronto began with great pomp and ceremony on October 15, 1851, following a grand parade through the streets of the city. The sod turning for Ontario's first railway, the Ontario, Simcoe & Huron (OS&H), was staged near Front and Simcoe streets. Lifting the ceremonial silver spade was the Countess of Elgin, the wife of the Governor General of Canada, the Earl of Elgin. (*Gleason's Pictorial Drawing-Room Companion*, January 24, 1852.)

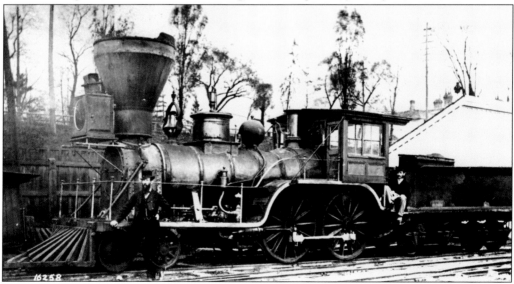

A year later the new railway took delivery of its first locomotive and named it the *Lady Elgin*. The engine was built in Portland, Maine, and sent by rail to Oswego, New York, where it was shipped across Lake Ontario by steamship, arriving on October 3, 1852. The OS&H was unhappy with the costs of customs duties and shipping and determined that its next locomotive would be built locally.

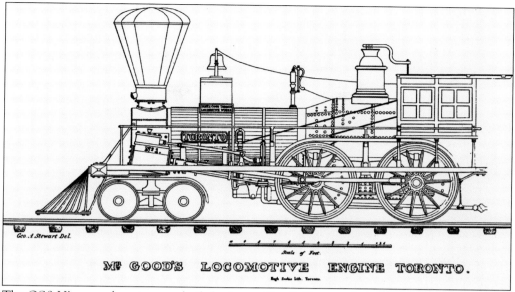

M^r GOOD'S LOCOMOTIVE ENGINE TORONTO.

The OS&H's second engine was built by James Good's Toronto Locomotive Works (TLW) at Queen and Yonge streets. It was the first steam locomotive manufactured in Canada or anywhere in the British Empire outside of England. This drawing is the only record of the *Toronto*'s actual appearance upon delivery. A later photograph shows the engine after it was extensively altered following an accident. (*Canadian Journal*, October 1853.)

James Good had to move the *Toronto* along Queen and York streets to the nearest tracks on Front Street. On April 16, 1853, the 30-ton engine began its ponderous five-day journey, which fascinated Torontonians who monitored its daily progress. This rendering of the event is charming but inaccurate since it shows the locomotive as it looked years later and accompanied by its tender, which was moved separately the day before.

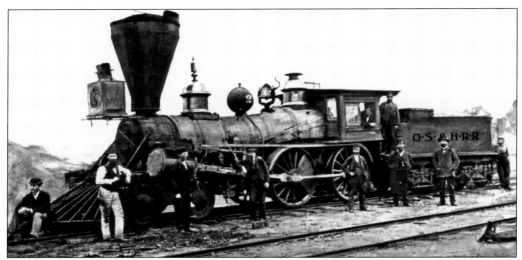

The locomotive *Toronto* hauled the first revenue passenger train in Ontario for the OS&H on May 16, 1853. The destination was Aurora, 30 miles to the north. The four-car train departed from a wooden depot located near the entrance to today's Union Station. This 1880s photograph shows the engine after it had been considerably altered, and it was scrapped shortly thereafter. (TPL, MTL 1825.)

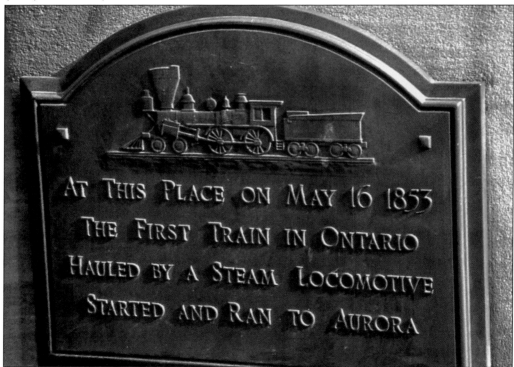

The OS&H was Ontario's pioneer railway. In 1953 this plaque was affixed to a column at the entrance to Union Station to commemorate the 100th anniversary of the first passenger train. Aurora is now a GO Transit stop 30 miles north of the city. The plaque was removed sometime in the 1990s and will be restored as part of the $640 million restoration of Union Station.

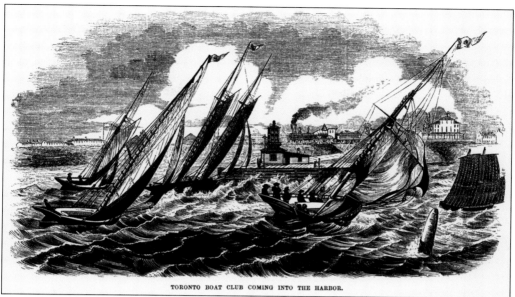

TORONTO BOAT CLUB COMING INTO THE HARBOR.

Photography was in its infancy when the railway era began in Toronto, and there are no known photographs of the first few years of operations. This 1853 engraving shows an OS&H locomotive passing by Queen's Wharf at the foot of Bathurst Street. By this time, the railway had been extended to Allendale, near Barrie, and would soon reach Collingwood. (*Gleason's Pictorial Drawing-Room Companion*, October 8, 1853.)

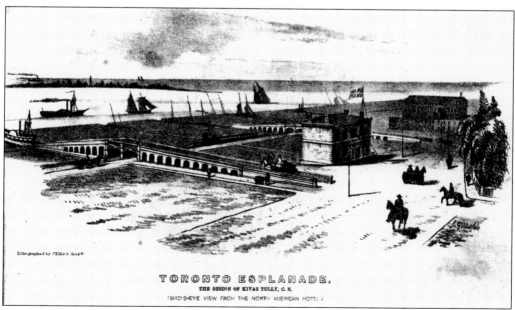

TORONTO ESPLANADE,
THE DESIGN OF KIVAS TULLY, C. E.
(BIRD'S-EYE VIEW FROM THE NORTH AMERICAN HOTEL)

From the beginning of the railway era, municipal authorities were concerned about tracks blocking public access to the waterfront. This 1853 plan by Kivas Tully looks southwest from Yonge Street. Tully envisaged gently sloping stone bridges carrying roads over a corridor known as the Esplanade, consisting of two tracks and a carriageway. The corridor was built; the bridges were not. The prominent building with the flag is the customs house.

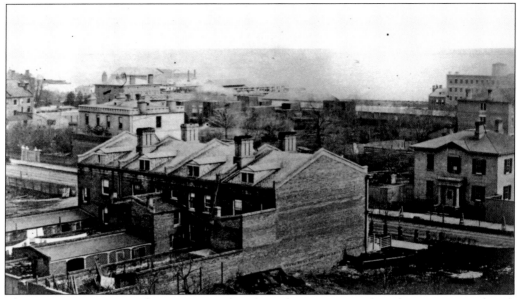

This 1857 image is part of a panorama taken from the Rossin Hotel rooftop at King and York streets. Wellington Street is behind the townhouses and Front Street bisects the middle. Barely discernible at the right of centre is the roof of the Grand Trunk Railway Bay Street station; to the right is the roof of the original OS&H station, the only known images of these stations. (CTA, fonds 1498, item 22.)

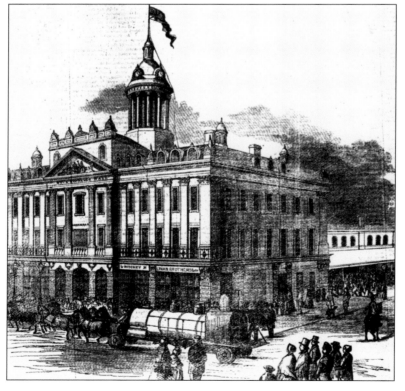

The TLW was seriously hindered by its inconvenient location a mile north of the rail corridor. This engraving shows a Grand Trunk Railway (GTR) engine in 1855 being hauled by horse teams past St. Lawrence Hall on King Street to the GTR shops near the Don River. After unsuccessfully trying to relocate to the waterfront, the TLW abandoned the railway business in 1859 after building 23 locomotives. (TPL, T30102.)

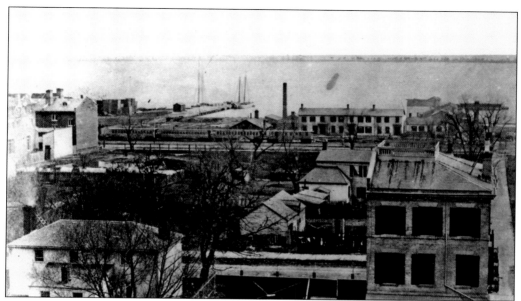

The adjacent image of the panorama on page 16 is the earliest known photograph of a train in Toronto. The York Street sidewalk is on the far right. Four Grand Trunk Railway passenger cars are shown on the south side of Front Street. Seventy years later, the present Union Station would occupy the entire block south of Front between Bay and York streets. (CTA, fonds 1498, item 23.)

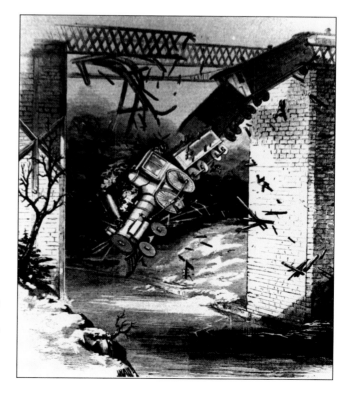

The most serious accident involving a train originating in Toronto occurred on March 12, 1857. At 5:45 p.m., a Great Western Railway (GWR) train was approaching the bridge over the Desjardin Canal near Hamilton. An axle on the locomotive broke and the bridge collapsed, plunging the train 60 feet to the frozen canal below and killing 59 people. It was the second-worst railway disaster in Canadian history.

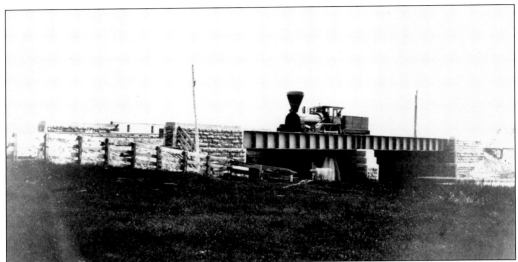

A GTR locomotive is westbound over the Don River in this *c.* 1858 view photographed two miles east of Union Station. The engine was one of 50 manufactured in England by the contractor who built the railway's Montreal–Toronto main line. The bridge was replaced in the 1920s, although portions of the stone abutment on the right can still be seen underneath the Don Valley Parkway. (NAC, PA 138692.)

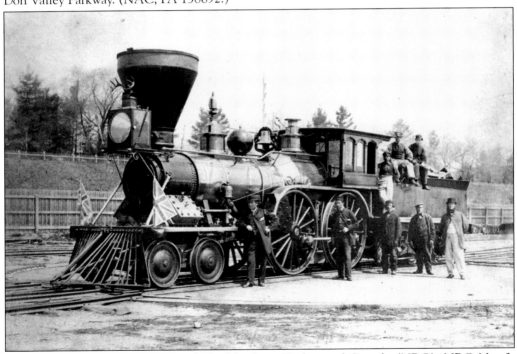

In 1858, the OS&H was renamed the Northern Railway of Canada (NRC). NRC No. 3, decorated with Union Jacks, poses on the turntable south of Front Street around 1860. The locomotive was called the *Josephine*, probably named for its longtime engineer Josiah Huckett, seen leaning on the running board. The *Josephine*'s enormous 72-inch driving wheels made it the fastest engine in the NRC roster. (CTA, series 575, item 19.)

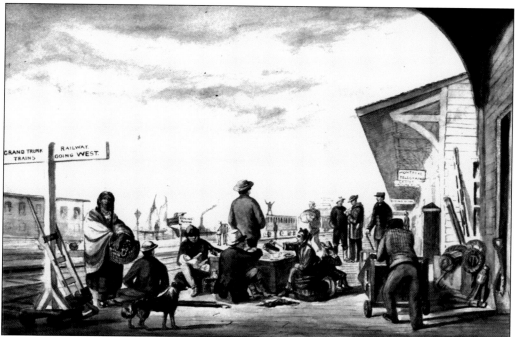

This 1860 watercolour by artist William Armstrong shows the first Toronto Union Station, built by the GTR in 1858. A family is picnicking on a wooden crate while a native woman waits with her basket. The uniformed official standing under the eave is probably the stationmaster. A GTR passenger train is being assembled on the tracks in front of the station. (TPL, MTL 1121.)

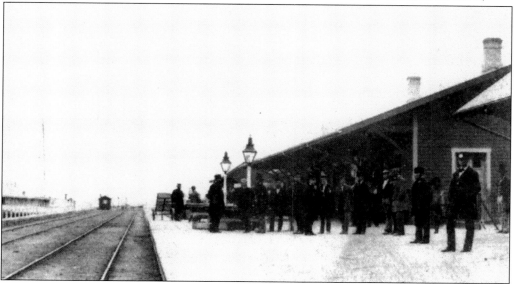

The poor quality of this image is mitigated by the fact that this may be the only photograph of Toronto's first Union Station. The perspective is similar to Armstrong's watercolour, and he may be the original photographer and based his painting, with some added artistic license, on this image. Armstrong was a multitalented artist and photographer who also photographed the Rossin House panorama. (NAC, 000945391.)

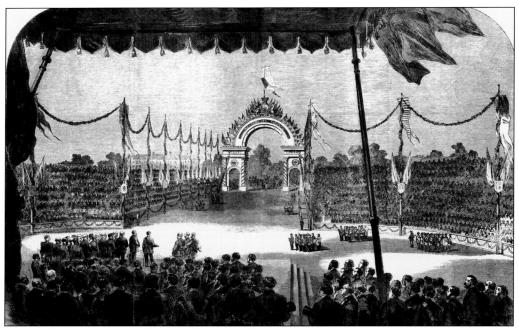

Edward, the Prince of Wales, visited Toronto in 1860 during his royal tour of North America. On September 7, the prince arrived by steamship and was greeted by thousands in this huge amphitheatre at the foot of John Street. The venue also served as a royal passenger station on the two occasions that the prince boarded a train during his visit to Toronto. (*Illustrated London News*, October 27, 1860.)

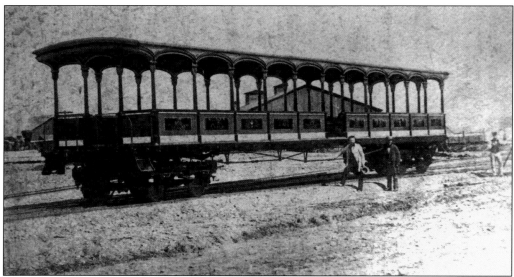

On September 10, Prince Edward (later King Edward VII) rode a special NRC train from the amphitheatre in Toronto to Collingwood and back. The NRC shops built this open observation car for the Royal Train, on which the prince spent much of the journey. The train attained the then-unheard of speed of 55 miles per hour on its return trip between King and Davenport stations. (CTA, series 575, item 18.)

The NRC's extensive Toronto terminal facilities are seen in this *c.* 1860 photograph taken from Queen's Wharf. From left to right are a white picket fence along Front Street, the eight-stall roundhouse, machine shop, car shop, passenger station, and freight house. On the far right is the GTR's domed roundhouse. The logs in the foreground are being assembled into huge timber rafts. (CTA, SC 347, item 8.)

This bleak winter view is looking east from the Bathurst Street bridge toward Brock Street around 1860. On top of the embankment on the left is Front Street, below it is the railway corridor leading west and north of the city. Occupying the centre of the photograph are the NRC facilities, and the GTR grain elevator is on the distant right. (CTA, series 575, item 3.)

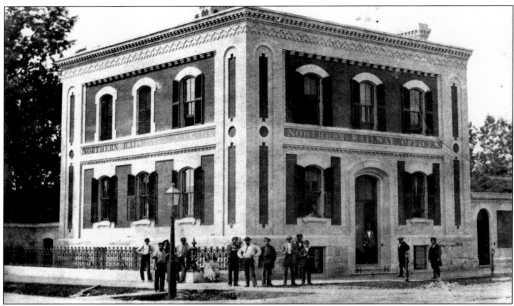

This 1862 view shows the recently completed NRC offices at Brock (Spadina Avenue) and Front streets. This compact building was designed by Toronto architect William G. Storm, who also designed the GWR Yonge Street passenger station and the extant St. Andrew's Presbyterian Church at King and Simcoe streets. This structure was later used for a railroad YMCA and was demolished in the 1920s. (CTA, SC 347, item 5.)

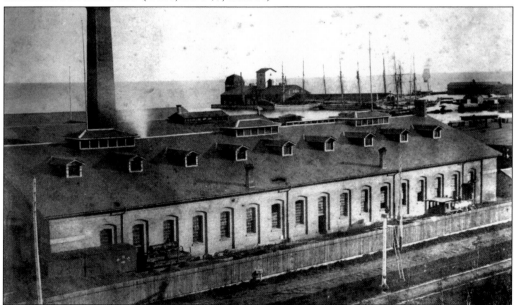

Another 1862 view is looking southwest from the corner of Front and Brock streets over the NRC's main line and machine shop. This building survived until the 1920s, when it was demolished to make way for Canadian National's Spadina engine facilities. At centre top is the NRC grain elevator. On the right is an unidentified locomotive at the shops for servicing. (CTA, series 575, item 2.)

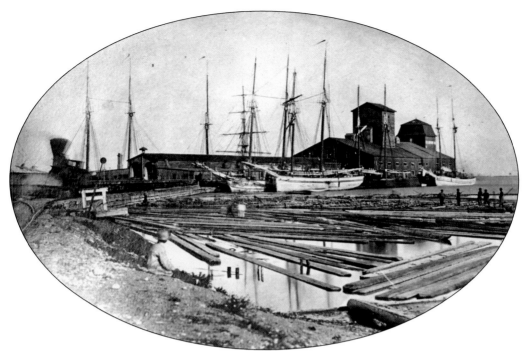

This 1862 photograph shows two profitable commodities carried by the NRC, whose moving locomotive has blurred the image. In the foreground are logs being assembled into huge timber rafts that will be towed to Quebec City and then disassembled for shipment to Europe. The dozen masts poking into the sky belong to schooners that will carry grain to the United States from the elevator at the foot of Brock Street. (NAC, 136475.)

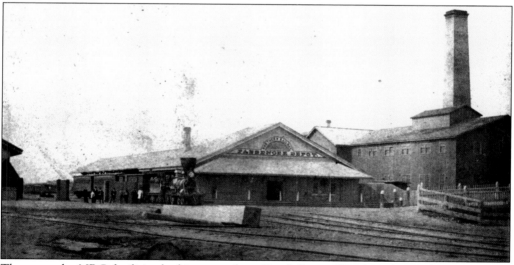

These are the NRC facilities looking west from Brock Street (Spadina Avenue) around 1862. The train at the passenger depot may have been manufactured entirely in Toronto. The locomotive is an 1855 product of the TLW; the two passenger cars were made at the Toronto Car Factory, only a few blocks from here. The origin of the baggage car is less certain. (CTA, SC 347, item 7.)

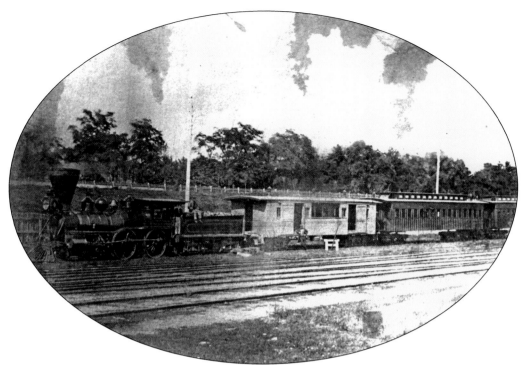

In 1862, an NRC passenger train posed for this photographer along the main line between Brock and Bathurst streets below the Front Street embankment. The passenger coaches are products of the Toronto Car Factory. The raised clerestory roofs provided better lighting and ventilation than earlier flat-roofed coaches. (CTA, series 575, item 17.)

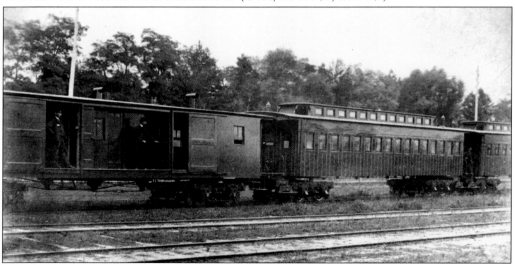

The Toronto Car Factory was established by the McLean, Wright & Company in 1852 to build 218 passenger and freight cars for the OS&H. The company was based in Montreal but the cost of shipping the completed cars made it more economical to establish a Toronto branch plant. The baggage car on the left has a separate locked room in the middle for express. (CTA, series 575, item 13.)

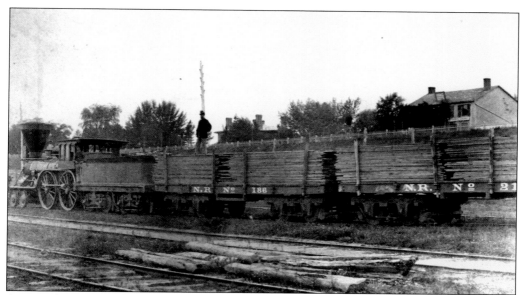

Among the most profitable freight carried by the NRC were lumber products milled from the vast tracts of forest north of the city. Early passengers even complained that the woods were so thick along the railway that they could not see any scenery from the coach windows. The platform cars shown here are two of the 153 manufactured for the railway at the Toronto Car Factory. (CTA, series 575, item 14.)

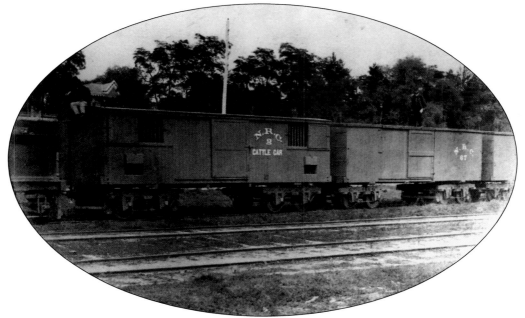

Two additional types of freight cars used by the NRC are seen in this view. For over 150 years, boxcars were the most ubiquitous freight car on the railways, used to carry everything that could fit inside, including grain. The cattle cars were boxcars modified with barred openings for ventilation. The transportation of livestock into Toronto by rail only ended in the 1980s. (CTA, series 575, item 15.)

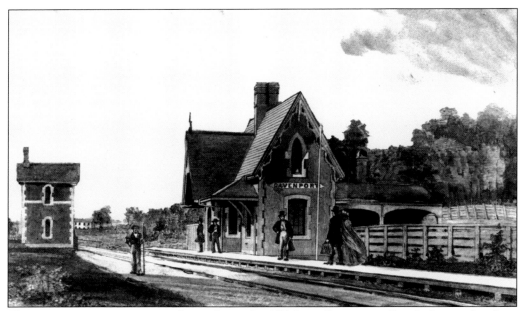

This picturesque station was located on the NRC at Davenport Road, four miles from downtown. The grounds were well manicured, and the otherwise utilitarian water tower on the left was built to aesthetically complement the passenger station. As early as 1855, real estate developers sold lots near here in an early attempt to promote a railway suburb with convenient rail access to the city. (*Canadian Illustrated News*, 1863.)

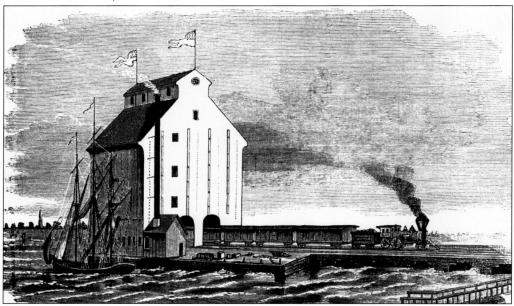

During the 1860s most of the grain transported from the American Midwest to the U.S. Eastern Seaboard came through Toronto by rail, saving several days of lake travel. The GTR built this elevator at the foot of Peter Street, which had a storage capacity of 200 000 bushels and could load 12 000 bushels an hour into lake vessels for shipment across Lake Ontario. (*Canadian Illustrated News*, April 18, 1863.)

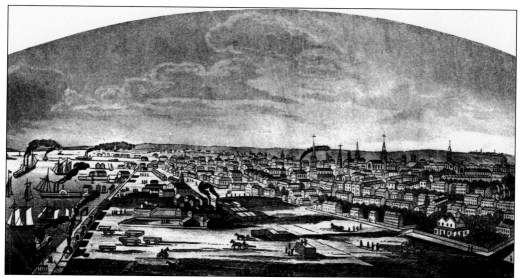

This panoramic view of the city in 1863 from near the Don River shows a single GTR rail line running along the waterfront, with a public promenade separating the track from the lake. The city's efforts to preserve the Esplanade were constantly thwarted by the GTR, which wanted to build several more tracks as rail traffic increased. (*Eighty Years' of Progress of British North America*, 1863.)

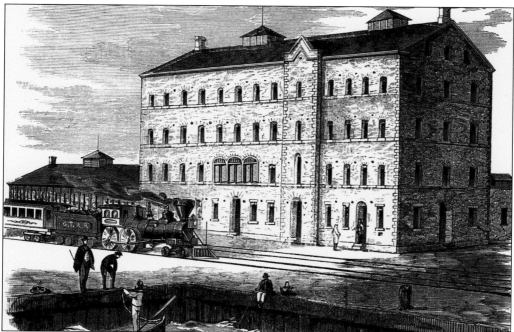

This engraving depicts an eastbound GTR passenger train passing in front of the Gooderham & Worts distillery building near Parliament Street in 1863. In 1856 the GTR had opened its railway line between Montreal and Toronto, linking Canada's two largest cities and reducing the travel time from days to hours. This building still exists as part of the Distillery District National Historic Site. (*Canadian Illustrated News*, April 25, 1863.)

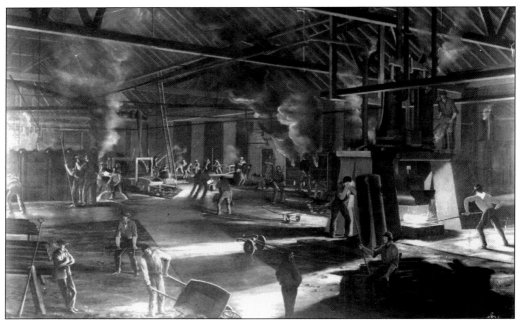

The Toronto Rolling Mills is luridly illustrated in this 1864 painting by the prolific William Armstrong. The formidable machine on the right is a steam hammer. The company was established by engineer Casimir Gzowski in 1857 to remanufacture worn-out iron rails and was the largest industry in Toronto, employing over 300 men. The company went out of business in 1873 after stronger steel rails became available. (TPL, MTL 10914.)

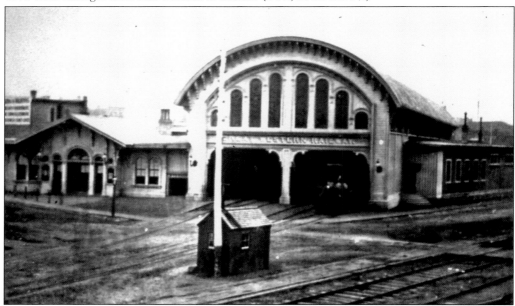

In 1866 the GWR vacated Union Station and built a new passenger station at the foot of Yonge Street. The Romanesque-style terminal was designed by William G. Storm. This was the first station in Toronto to provide a covered train shed and was conveniently located adjacent to the steamship wharves, the city's better hotels, and the central business district. (TPL, T12181.)

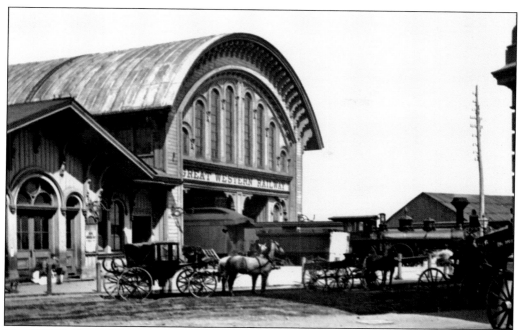

The GWR's Yonge Street station is seen here in 1867, a year after it opened. Horse-drawn cabs wait by the curb to transport passengers to their local destinations. This location was far more convenient than the railway's original passenger station at the foot of Bathurst Street or even Union Station at York Street, which was located several blocks west of the commercial core of the city. (OA, 10021822.)

On June 10, 1867, the NRC opened the City Hall station near the foot of Jarvis Street. Among those attending was John A. Macdonald, who three weeks later would become the first Prime Minister of the Dominion of Canada. Many NRC passengers were farmers bringing products to the adjacent market. The station was demolished around 1894, and the site is now occupied by the south end of St. Lawrence Market. (OA, 10021842.)

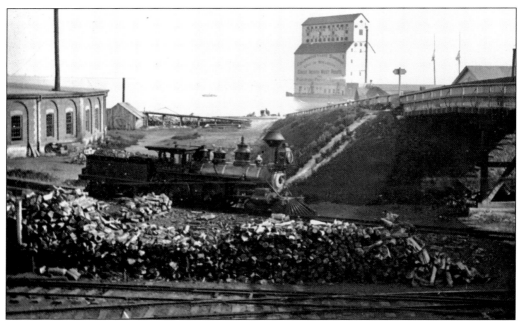

A GTR 4-4-0 engine waits behind the woodpile in the shadow of the Brock Street bridge. The vast quantities of wood required by locomotives helped denude the forests of southern Ontario until the railways began using coal in the 1870s. The GTR roundhouse can be seen on the left, and the elevator is festooned with advertising for the NRC steamship service. (OA, 10021839.)

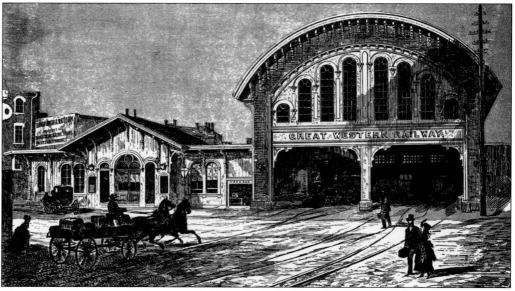

The GWR was Ontario's first great railway network. By 1870, the date of this engraving, the GWR stabled 133 locomotives, 129 passenger cars, 31 baggage and mail cars, and 1737 freight cars that operated on 484 miles of track. In 1855 the GWR opened the Suspension Bridge at Niagara Falls that provided a direct rail link between Toronto and New York City. (*Canadian Illustrated News*, April 2, 1870.)

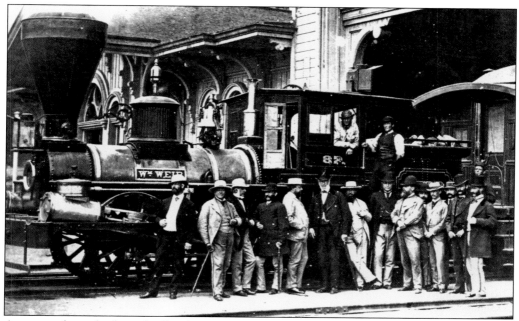

A group of nattily dressed officials poses in front of the GWR's No. 87 at the Yonge Street station. William Weir was a director of the company, possibly one of the individuals in the photograph. The locomotive was built as the wide-gauge 4-4-0 No. 8 *Erie* in 1853 and rebuilt in 1871 to the standard-gauge 0-4-4T configuration shown here.

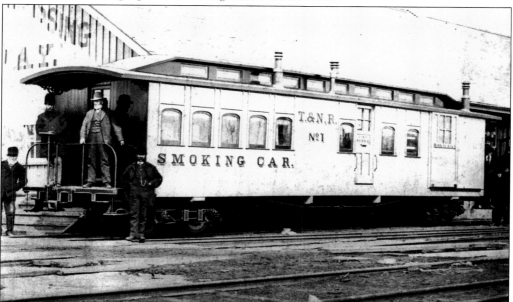

This unusual passenger car was on the roster of the narrow-gauge Toronto & Nipissing Railway (T&N) that ran northwest of the city to Coboconk. It is seen here in 1871 outside the Berkeley Street station. The car was built by the nearby St. Lawrence Foundry and featured a smoking compartment, baggage room, and post office in the middle, complete with a slot for depositing mail. (CTA, series 718, item 6.)

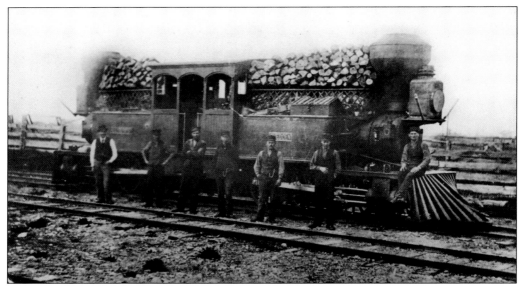

This bidirectional locomotive was built in 1871 for the T&N by the Avonside Engine Company in England. The engine is seen here at Scarborough Junction and was named after John Shedden, the T&N president who was accidentally crushed to death by one of his own trains in 1873. The *Shedden* blew up at Stouffville in 1874, killing some of the men in this photograph. (CTA, series 718, item 5.)

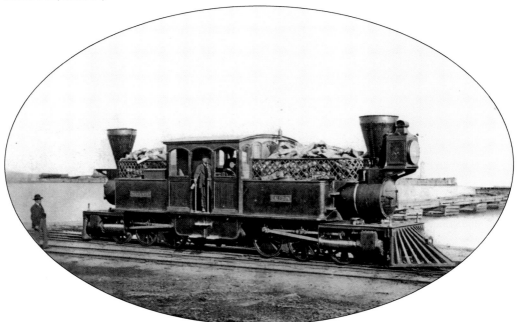

Avonside also built 12 locomotives for the Toronto, Grey & Bruce Railway (TG&B) that ran northwest of the city to Owen Sound. No. 7 was named *Caledon* and was the railway's only Fairlie, featuring two boilers joined back-to-back by a common firebox that divided the central cab. The engine is seen here about 1871 near the TG&B facilities at Queen's Wharf south of Fort York. (CTA, series 718, item 4.)

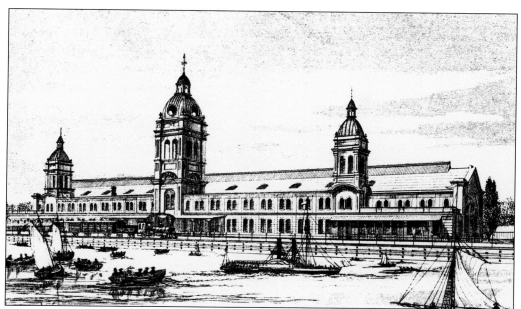

In 1871 the GTR demolished the first Union Station and built this magnificent replacement on the same site west of York Street. When the station opened on July 1, 1873, it was by far the largest passenger station ever built in Canada. In this 1873 rendering that was published a month after the station opened, the clock still was not installed in the tower. (*Canadian Illustrated News*, August 2, 1873.)

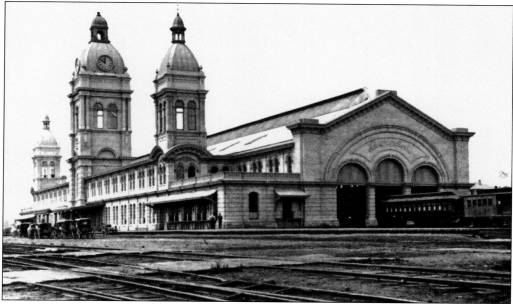

The white brick and stone used to construct Union Station did not remain pristine for long, given the heavy pollution of that era. At the bottom of this view is York Street, which provided pedestrian and vehicular access from the city. As the frequency and length of trains increased, this proved to be a serious design flaw that was not resolved until 1896, when the station was rebuilt. (NAC, PA103141.)

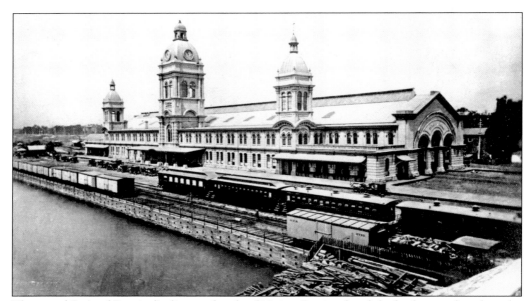

The grand Second Empire/Italianate facade of Union Station faced the harbour rather than the city, underscoring the continuing importance of lake travel well into the railway era. Initially Union Station did not serve the NRC and GWR although their trains halted in front of the station as a convenience for passengers changing trains. Both railways were taken over by the GTR in the 1880s. (TPL, T31104.)

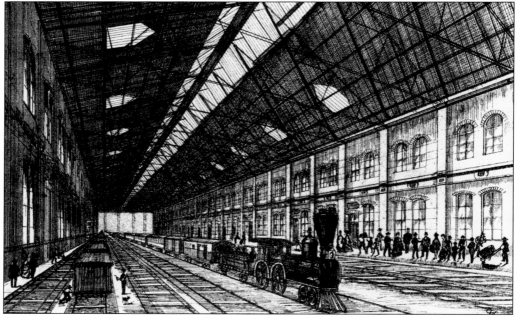

This exaggerated illustration shows the interior of the Union Station train shed covering at least seven tracks and about a quarter mile long. Although the shed was the largest in Canada at that time, it was considerably more modest in dimensions. People then were allowed to mill about on the platforms between trains, and this led to serious congestion during busy travel periods. (*Canadian Illustrated News*, August 2, 1873.)

The actual train shed had three tracks and was 470 feet long, with skylights overhead to brighten the interior. The two tracks on the left were for the GTR and conformed to the wide gauge of five feet, six inches between the rails. The track on the right was the narrow gauge of three feet, six inches built for the TG&B that began operations in 1869. (TPL, MTL 1794.)

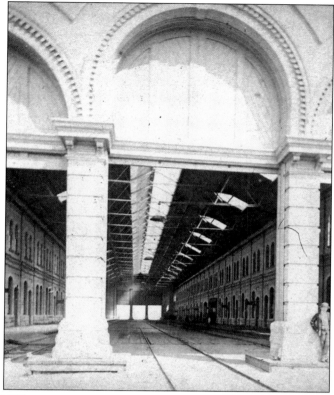

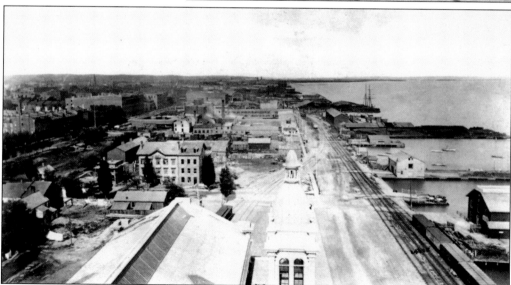

This 1873 view is looking east from the centre clock tower of Union Station, a popular vantage point for Torontonians to visit at that time. In the centre distance is the arched train shed of the GWR's Yonge Street station. York Street runs from north to south just beyond the station. Most of the space east of York would later be occupied by the present Union Station. (TPL, T31103.)

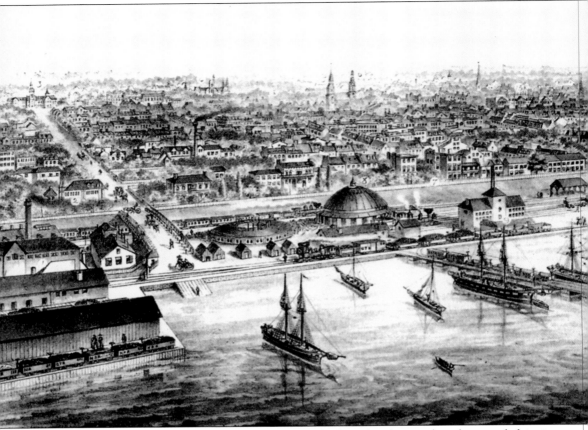

This 1873 bird's-eye view shows a busy Toronto harbour bustling with railway and shipping activity. The bridge over the tracks on the left is Brock Street (Spadina Avenue). Left of the bridge are the Northern Railway facilities seen on pages 21–23. To the right of the bridge are the two roundhouses of the GTR. The large domed roundhouse was demolished in the 1890s, but 100 years later, Skydome, the world's first retractable domed stadium, would occupy the same site. The building facing the harbour with the raised centre roof is the city water works. The

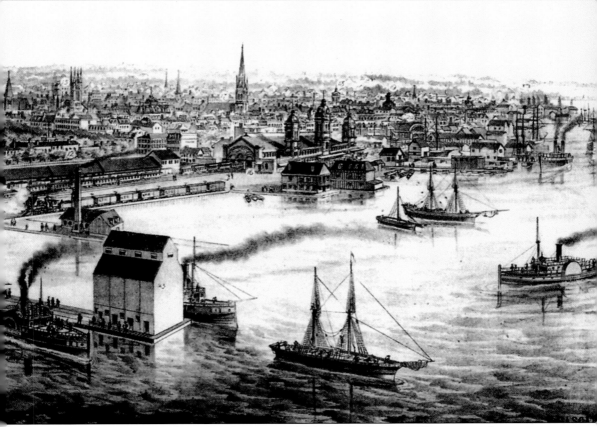

large elevator belongs to the GTR; above it on the left is the Pumping Station, sending water to the Rosehill Reservoir five miles to the northeast. Above the pumphouse is the GTR freight shed, with Union Station to the right of it. The tall steeple beyond the station is St. James Cathedral; for a few years it was the tallest structure in North America. The Toronto Railway Heritage Centre now occupies the centre of this view.

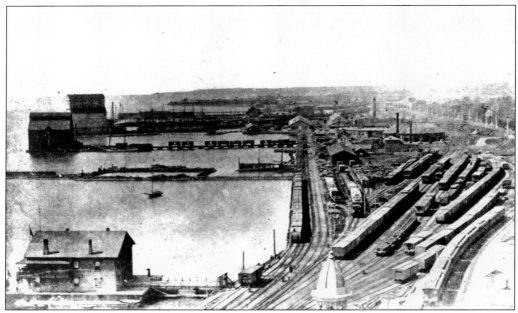

In the summer of 1873 this was the view looking west from the new Union Station clock tower. Front Street is indicated by the line of telegraph poles on the right. In the centre is the GTR rail corridor from 1858 to 1873, relocated by this time to where the long row of passenger cars can be seen on the lower right. (NAC, PA 200642.)

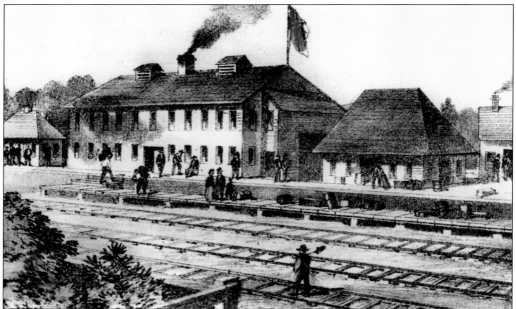

In the 1870s thousands of immigrants from Britain, Ireland, and Scotland were coming through Toronto, many of them to settle on agricultural land granted by the government. To help prevent these migrants from being exploited when they arrived, the authorities established an immigration depot on the south side of the GTR and NRC railways east of Strachan Avenue. The depot dispensed official assistance, advice, and temporary lodgings. (TPL, T30669.)

Two

COMPETITION, COOPERATION, AND CONSOLIDATION

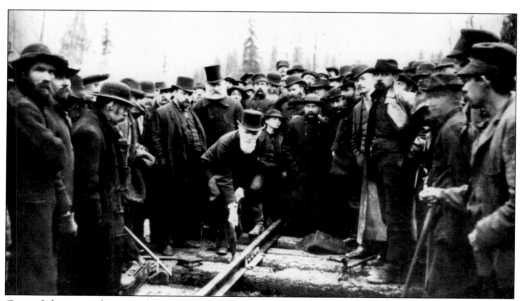

One of the most famous photographs in Canadian history depicts the driving of the last spike in British Columbia of the Canadian Pacific Railway (CPR) in 1885. The bearded gentleman with the tall hat is Torontonian Sandford Fleming, who was present at the OS&H sod turning in 1851. Fleming helped build both railways, as well as the Intercolonial Railway, and was one of Canada's most distinguished engineers and scientists.

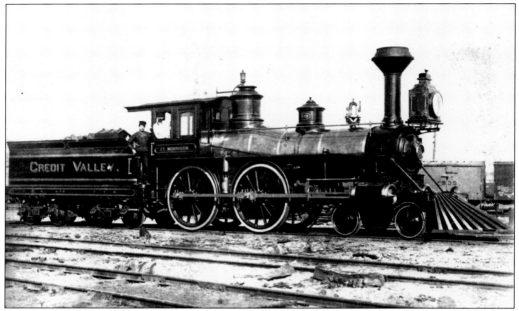

The Credit Valley Railway (CVR) began operations between Toronto and Milton in 1877 and was extended to St. Thomas in 1881. This attractive locomotive was built in 1881 by the Canadian Locomotive Company in Kingston and was named after one of the CVR's directors. The CVR was taken over by the CPR in 1884, and the route now carries one of GO Transit's busiest commuter lines.

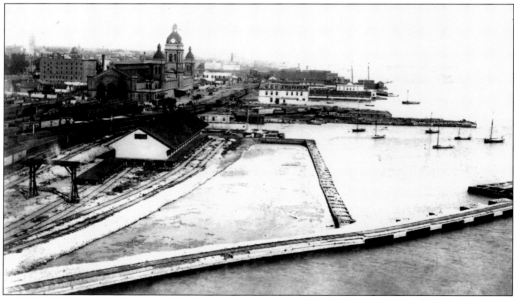

This 1884 view is looking east toward Union Station from the top of the municipal water pumping station at the foot of John Street. The large freight shed was built by the CVR, which by this time had been absorbed by the CPR. In 1897 the CPR opened the first John Street locomotive roundhouse on landfill in the centre of this view. (TPL, T10361.)

This 1884 view is looking north toward the intersection of Front and John streets. The long freight shed with the white roof survived until 1935, when it was consumed in a spectacular fire. On the upper right is the west end of the 1832 Parliament Buildings, replaced in 1893 by Queen's Park. The site was later occupied by the GTR's Simcoe Street freight yards. (TPL, T10360.)

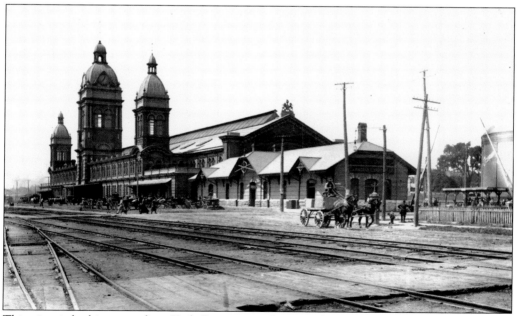

This view is looking west from York Street around 1884. The centre building is the new depot for the Canadian/American Express Company, later purchased by the GTR in 1892. The express delivery of small packages and valuables was usually carried on fast passenger trains in sealed compartments, and the depots were located adjacent to passenger stations. For many years, this lucrative business was virtually a railway monopoly. (NAC, PA146822.)

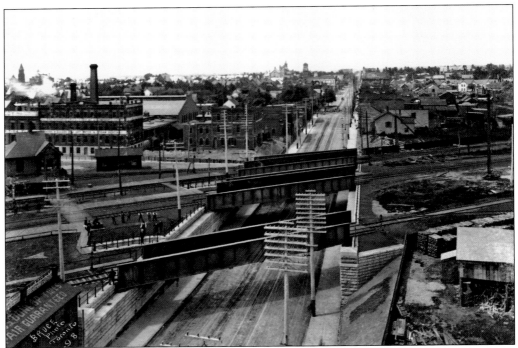

In 1884, the first grade-separated subway was built over Queen Street. Four different railways came through Parkdale along this corridor: (from top to bottom) the TG&B, the CVR, the GTR, and the NRC. The cost of this structure almost bankrupted Parkdale and delayed its annexation by Toronto. The subway was later rebuilt and is seen here in 1898. (CTA, series 276, fonds 2, item 1.)

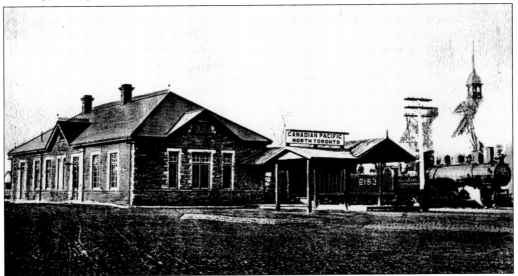

In 1883 the GTR enjoyed a monopoly on railway operations in the Toronto area. However, this advantage ended when the CPR opened a line between Montreal and Toronto in 1884 and acquired the TG&B and CVR to access downtown. The CPR built a station at Yorkville, which was annexed by the City of Toronto in 1884. The station was renamed North Toronto.

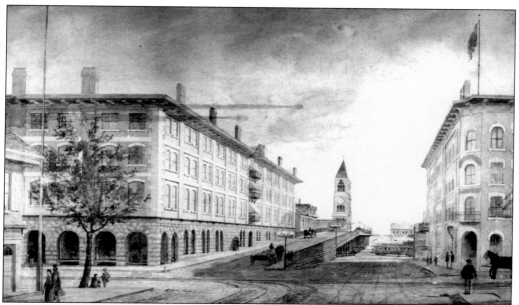

In 1886 the CPR planned a new passenger station at the foot of York Street, indicated here by the clock tower. Road access was to be by a U-shaped iron bridge above the tracks and extending over to Yonge Street. The building on the left was to be an elaborately decorated warehouse. The scheme was never realized, and the site is now occupied by Union Station. (TPL, 1289)

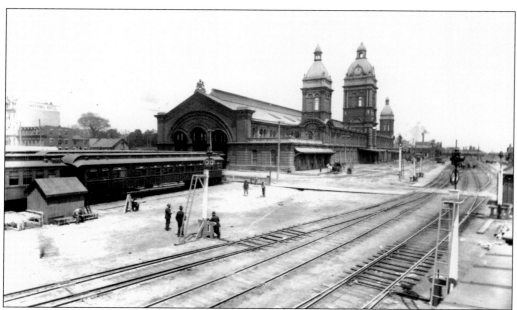

On the left is the new Pullman Palace car *Canadian*. Built at the GTR's Point St. Charles shops in Montreal, the 71-foot car contained 10 sections, a drawing room, a buffet, and a smoking room, the interior elaborately decorated in a Louis XV style. In the early 20th century Pullman sleeping cars hosted 100 000 people a night and operated throughout North America until 1969. (NAC, PA 146821.)

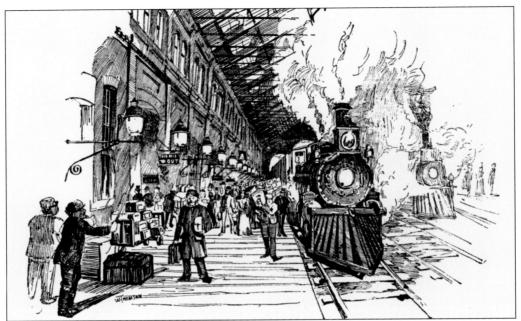

On February 22, 1890, the *Saturday Globe* devoted the front page to a history of Toronto railways, complete with engravings illustrating progress since 1853. The bustling interior of the Union Station train shed is captured by staff artist W. Thomson in this view looking west. The gaslight fixtures on the wall would not have provided sufficient illumination for the cameras of the era to capture such an active interior scene.

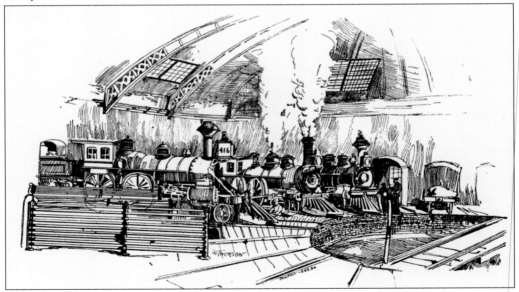

In 1860 the GTR built a rare, completely enclosed domed roundhouse between Brock Street (Spadina Avenue) and Peter Street that can be seen on page 36. One can only imagine what the lighting and working conditions must have been like for shop employees. Locomotive No. 416 was built in 1874 by the Manchester Locomotive Works in New Hampshire and carried the somewhat ominous name of *Earthquake*.

In 1876 the *Globe* newspaper began operating a special train over the GWR, departing Toronto before dawn in order to guarantee morning delivery to southwestern Ontario. Publisher and Father of Confederation George Brown had kept the *Globe* solvent by selling firewood to the GWR when it ran through property he had acquired so he could run for a parliamentary seat. The *Globe Flyer* is seen here in 1890.

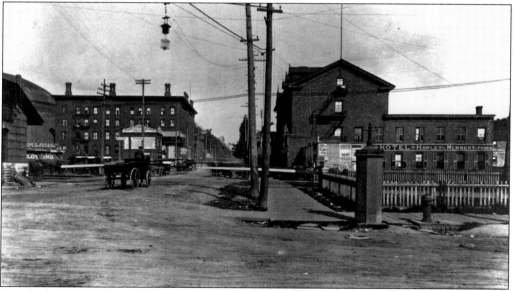

Hotels cluster around Union Station in this 1892 view looking north on York Street. The building on the right is the St. James Hotel, dating back to 1835. Farther north across the street is the Walker House Hotel, which survived until 1975. Behind the horse and wagon is a GTR ticket office, established here to relieve overcrowding inside the station. (CTA series 376, volume 16, item 6.)

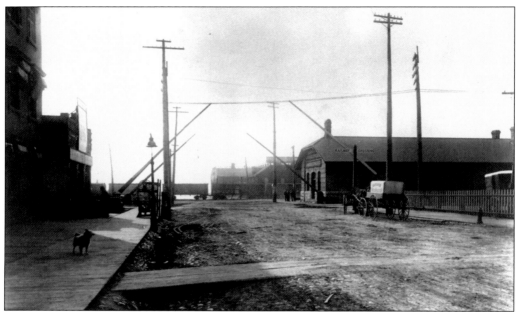

A fruit and confectionary delivery wagon waits by the curb in this view looking south on York Street in 1892. The Canadian Express building is on the right, and a freight train is crossing the bottom of the street. A railway employee farther down the sidewalk from the dog is operating the mechanism controlling the gates that protect the crossing. (CTA, series 376, volume 16, item 7.)

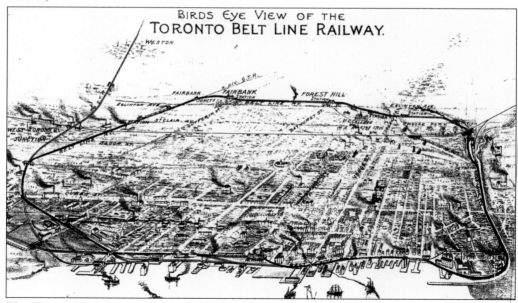

The Toronto Belt Line Railway (TBL) began in 1892 as a circular commuter train operation connecting downtown Toronto with the city's rapidly expanding northern and western suburbs. The Yonge Street Loop, seen here in a promotional brochure, used existing GTR track to access downtown Toronto and Union Station. Eight miles of new track were built through the Don Valley, Moore Park, and Forest Hill to Fairbank.

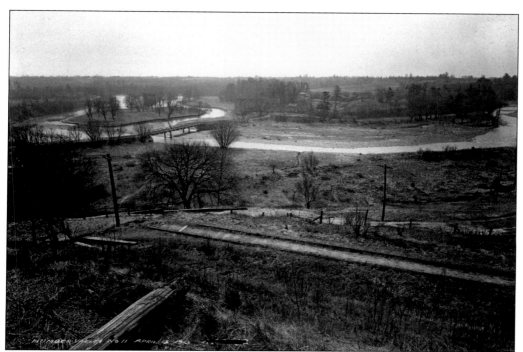

The TBL also included the separate Humber Loop, shown here in 1913 long after it had been abandoned. The western loop ran from the GTR main line at Swansea, north along the eastern rim of the Humber Valley, seen here, to West Toronto, and back to the GTR main line. The TBL shut down in 1894 after only two years of operation. (CTA, fonds 1231, item 294.)

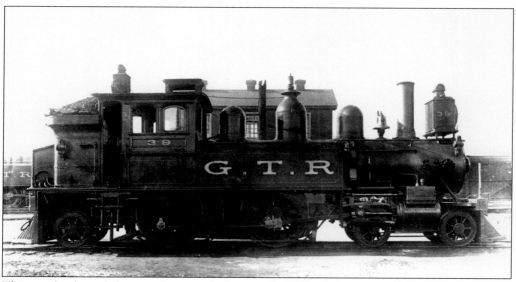

This may be the only known photograph showing the TBL while it was still in operation. No. 39 was one of five 4-4-2 side tank locomotives built by the GTR at its Point St. Charles Montreal shops for TBL service. On the right is the old NRC roundhouse west of Spadina while a sister locomotive can be seen on the left. (Al Paterson.)

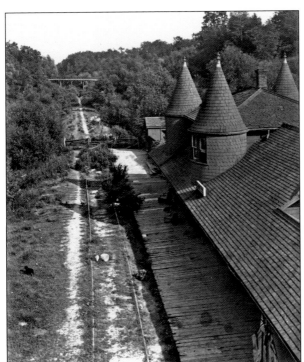

The TBL built some substantial passenger stations, including one at Moore Park, shown in 1909, 15 years after the railway ceased operations. The station was then being used as a residence, as evidenced by the rocking chairs and domestic animals. The rails were taken up in World War I and shipped to France. The bridge in the background links Heath Street and Clarence Avenue. (CTA, fonds 1244, item 1109.)

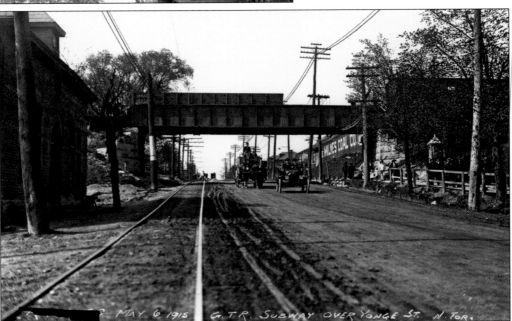

After the TBL shut down, the GTR used the northern section from Fairbank to Mount Pleasant as a freight line. The bridge over Yonge Street is seen in 1915, with the electric line of the Toronto & York Radial Railway passing underneath. Canadian National continued to operate freight trains here until 1970, when the new Allan Road severed the eastern part of the line. (CTA, fonds 1231, item 485.)

Long after it closed, pedestrians used the TBL as a walking trail and shortcut to downtown, a tradition that has continued into the 21st century. In 1906 this section of the TBL was used by the Canadian Northern. The track on the upper right is the CPR Don Branch. Between 1915 and 1919 the City of Toronto built the Bloor Street Viaduct at this location. (*Art Work on Toronto*, 1898.)

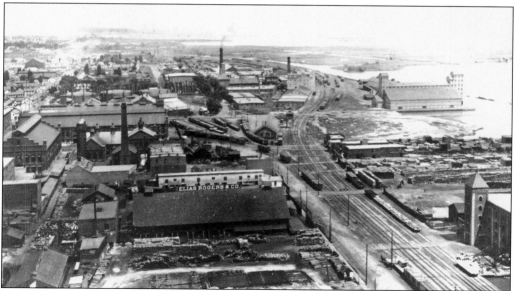

This 1894 view is looking east from the chimney of the Toronto Railway Company powerhouse. The small building surrounded by tracks was the passenger station of the T&N. Several of the structures seen here still exist, including the Gooderham & Worts Distillery at centre top and the Consumer's Gas structures on the left, which now house the Canadian Opera Company and a Toronto police division. (TPL, T32154.)

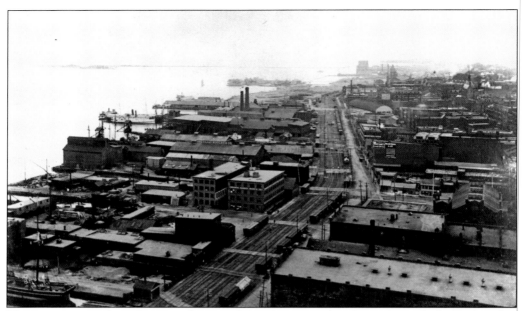

The western view from the same chimney shows the six-track rail corridor with the Esplanade a narrow road on the north side. The street running between the rows of boxcars straight through to the docks is Jarvis. The vacant lot to the west of it was the site of the NRC's City Hall station. In the distance is Union Station. (CTA, series 376, file 1, item 67.)

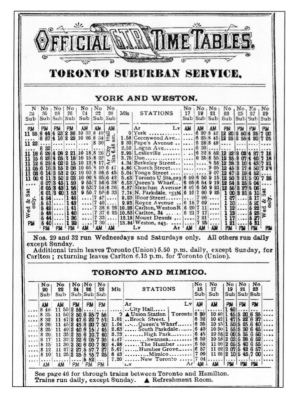

OFFICIAL G.T.R. TIME TABLES.

TORONTO SUBURBAN SERVICE.

YORK AND WESTON.

N 32 Sub	No 36 Sub	No 28 Sub	No 26 Sub	No 24 Sub	No 22 Sub	No 20 Sub	Mls	STATIONS	No 17 Sub	No 19 Sub	No 21 Sub	No 23 Sub	No 25 Sub	No 27 Sub	No 29 Sub
PM	PM	PM	PM	AM	AM	AM		Ar Lv	AM	AM	AM	PM	PM	PM	PM
11 55	6 44	6 23	2 38	10 33	8 10		0	York	6 20	8 12	12 30	2 50	6 25	7 00	
....	6 37	6 16	2 29	10 26	8 34		1.58	Greenwood Ave.....	6 25	8 45	12 25	2 55	6 30	7 05	
11 23	8 30		2.33	Pape's Avenue ...	6 28	8 48					
....	6 32		2.59	Logan Ave......	6 30						
11 18	6 28	4 08	2 21	10 18	8 26		2.95	Leslieville	6 32	8 52	12 32	3 02	6 37	7 15	
11 15	6 26	4 05	2 18	10 15	8 22		3.75	Don....	6 35	8 55	12 35	3 07	6 40	7 18	
11 12	6 23	4 02	2 15	10 12	8 17		4.34	Berkeley Street..	8 58	12 38	3 10	6 43	7 21	
11 05	6 16	3 55	2 09	10 05	8 10	6 47	4.86	Church Street....	9 05	12 45	3 17	6 50	7 29	
11 08	6 14	3 53	2 06	10 03	8 08	6 45	5.04	Yonge Street	9 07	12 47	3 19	6 52	
11 00	6 11	3 50	2 03	10 00	8 05	6 42	5.43	Toronto U Sta.,223	6 00	9 15	12 50	3 21	5 00	7 35	
....	6 07	3 45	1 59	9 55	7 56	6 38	5.63	Queen's Wharf...	6 05	6 54	9 19	12 54	3 25	5 04	
....	6 05	3 43	1 56	9 53	7 54	6 36	6.87	Strachan Avenue	6 07	6 56	9 21	12 56	3 27	5 06	
Wed & Sat only	6 01	3 40	1 53	9 50	7 50	6 33	7.74	N. Parkdale, 153¾	6 10	7 00	9 25	1 00	3 31	5 10	
	5 54	1 46	7 43	9.23	Bloor Street.....	7 06	1 07	5 17	
	5 51	1 43	7 40	9.95	Royce Avenue	6 18	7 09	1 10	5 20
	5 49	1 41	7 38	6 26	10.28	Carlton, WestonR	6 20	7 11	1 12	5 22	
	5 48	1 40	7 37	6 25	10.53	Carlton, 34	6 21	7 17	1 15	5 23	
	5 44	1 36	7 33	12.18	Mount Dennis	7 21	1 17	5 27	
PM	5 40	1 32	7 30	13.84	Weston, 243.	7 25	1 21	5 31	
	PM	PM	PM	AM	AM	AM		Lv Ar	AM	AM	AM	PM	PM	PM	PM

Nos. 29 and 32 run Wednesdays and Saturdays only. All others run daily except Sunday.
Additional train leaves Toronto (Union) 5.50 p.m. daily, except Sunday, for Carlton ; returning leaves Carlton 6.15 p.m. for Toronto (Union).

TORONTO AND MIMICO.

No 20 Sub	No 22 Sub	No 24 Sub	No 26 Sub	No 28 Sub	Mls	STATIONS	No 15 Sub	No 17 Sub	No 19 Sub	No 21 Sub	No 23 Sub
AM	AM	PM	PM	PM		Ar Lv	AM	AM	PM	PM	PM
8 40	11 55	2 55City Hall....	1 40
8 35	11 50	2 50	6 25	7 55	0	▲Union Station Toronto	6 30	10 40	1 45	5 30	6 35
8 32	11 47	2 47	6 22	7 52	1.01	..Brock Street.	6 32	10 42	1 47	5 22	6 37
8 30	11 45	2 45	6 20	7 50	1.04	...Queen's Wharf..	6 35	10 45	1 50	5 25	6 40
8 25	11 40	2 40	6 15	7 42	2.63	..South Parkdale..	6 40	10 50	1 55	5 30	6 45
8 20	11 35	2 35	6 10	7 40	3.73High Park....	6 45	10 55	2 00	5 35	6 50
8 17	11 32	2 32	6 05	7 35	4.47Swansea....	6 50	10 58	2 03	5 38	6 52
8 13	11 30	2 30	6 00	7 30	4.98	...The Humber..	6 55	11 00	2 05	5 40	6 55
8 12	11 27	2 27	5 57	7 27	5.67	..Humber Grove..	6 57	11 02	2 07	5 42	6 57
8 10	11 25	2 25	5 55	7 25	6 43Mimico.....	7 00	11 05	2 10	5 45	7 00
....	5 52	7.20	...New Toronto ...	7 04
AM	AM	PM	PM	PM		Lv Ar	AM	AM	PM	PM	PM

See page 46 for through trains between Toronto and Hamilton.
Trains run daily, except Sunday. ▲ Refreshment Room.

In the early 1890s, the GTR provided a commuter train operation that was apparently unsuccessful, since it was gone by the beginning of the 20th century. Toronto would not see another extensive commuter rail system until the inception of the GO Transit Lakeshore operations in 1967. Like the York and Weston service of the 19th century, GO would use Union Station as a hub with east–west trains passing through the facility.

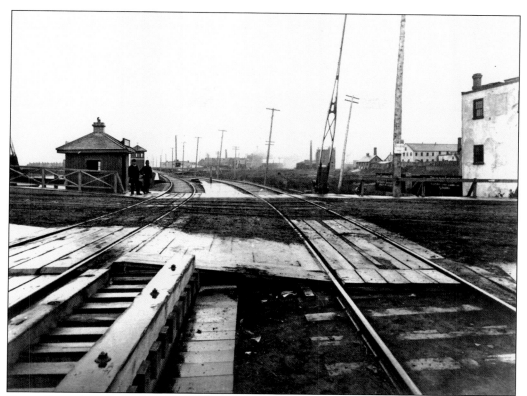

Queen Street bisects the centre of this *c.* 1894 photograph. On the right is the TBL; on the left is the new CPR Don Branch from Leaside. The small building on the left is the TBL Queen Street East station. In 1896, the CPR replaced this with the Don station. Behind the two gentlemen is an interlocking tower protecting the crossing. (CTA, series 376, volume 1B, item 3.)

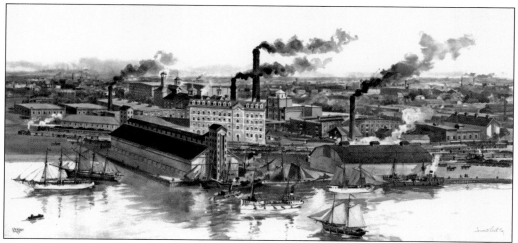

The Gooderham & Worts Distillery benefited considerably from its ability to ship products all over North America by rail. By the 1890s, when this lithograph was produced, it was the largest industrial concern in Toronto and the most prodigious distillery in Canada, producing one third of Canada's total output. The Gooderhams also financed the T&N and the TG&B.

The St. James Hotel on York Street is being demolished in order to accommodate the new bridge over the railway tracks in this 1896 scene. The recently completed Union Station additions are on the left. The Cyclorama, the round building beside the station, is showing "Jerusalem," a life-size series of paintings depicting the ancient biblical city. In the foreground, work is ongoing on the massive expansion of the rail yards.

In 1882 the GTR absorbed the GWR and moved its passenger trains from Yonge Street to Union Station. The 1866 station then became a bonded freight depot and is seen here around 1898 looking north on Yonge Street. The only building still standing is the Bank of Montreal to the left of centre, now the Hockey Hall of Fame. (CTA, series 376, volume 4, item 26.)

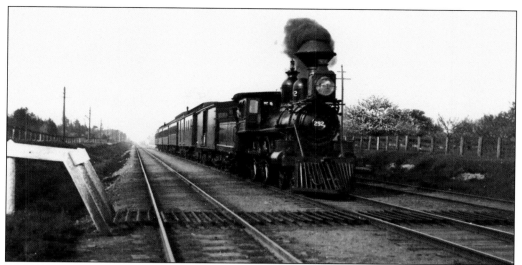

GTR 4-4-0 No. 292 speeds a passenger train west out of Toronto just before the start of the 20th century. Photographs from that era of trains in motion are quite rare. The wooden slats across the tracks are a cattle guard designed to keep errant livestock off the tracks, a persistent problem in the early railway era since they were capable of derailing light engines. (CTA, fonds 1244, item 1081.)

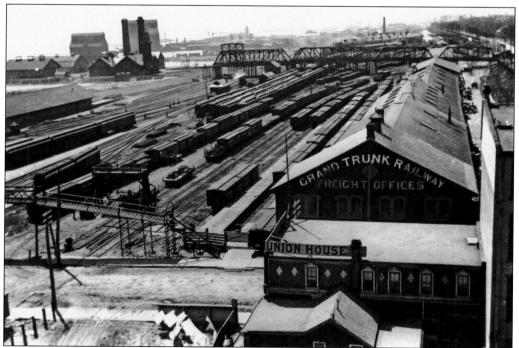

This 1897 scene is looking west from Simcoe Street. The GTR freight shed extends to John Street, where a new bridge is under construction since a number of streets were closed off to rebuild Union Station. The "Bridge of Sighs" can be seen on the lower left, so called for the weary immigrants who carried all their worldly belongings over the bridge after they arrived in Toronto. (NAC, PA200651.)

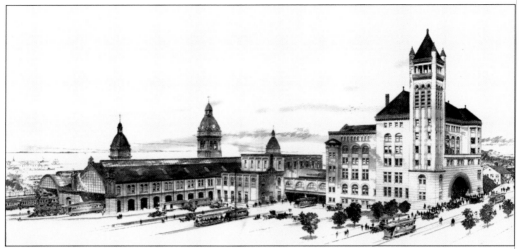

This rendering shows the alterations to the 1873 Union Station that were carried out in the 1890s. The new Romanesque-style headhouse with a nine-storey tower provided a grand entrance from Front Street. Passengers proceeded through an arcade over Station Street into the original station and the new train shed to the south. A number of important streetcar lines also converged here. (*American Architect and Building News*, July 23, 1894.)

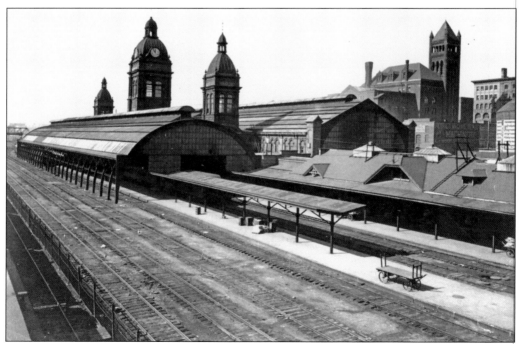

The alterations to Union Station are clearly illustrated in this view looking northwest from York Street. On the left is the new three-track train shed, a more utilitarian structure than the original shed, which was itself heavily modified. The low building on the right is the Canadian Express facility, while above it is the new headhouse on Front Street. (CTA, fonds 1244, item 5044.)

An imposing Romanesque arch greeted passengers entering the station from Front Street. The headhouse was designed by Toronto architects Strickland & Symons and copied the Illinois Central station in Chicago. The tower complemented the new city hall tower then under construction at Queen and Bay streets, although the new station did not have a clock since the older station already had this feature. (*Art Work on Toronto*, 1898.)

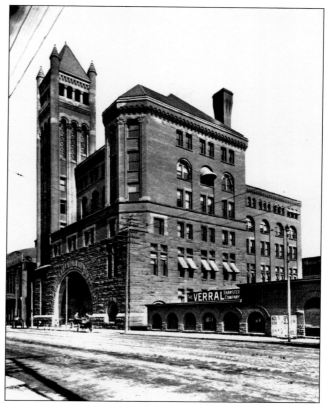

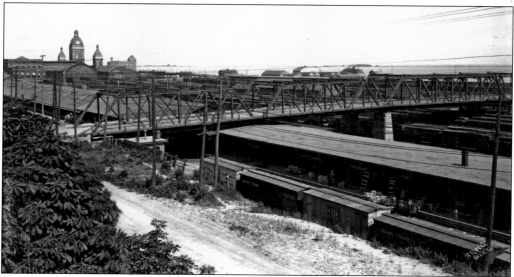

The John Street bridge is seen around the beginning of the 20th century with Union Station on the upper left. The bridge was completed in 1897 at the same time as the new CPR roundhouse, which was informally named after the newly extended street. The structure occupying the centre of the photograph is a GTR freight shed. The bridge was dismantled in 1929. (CTA, series 376, item 100.)

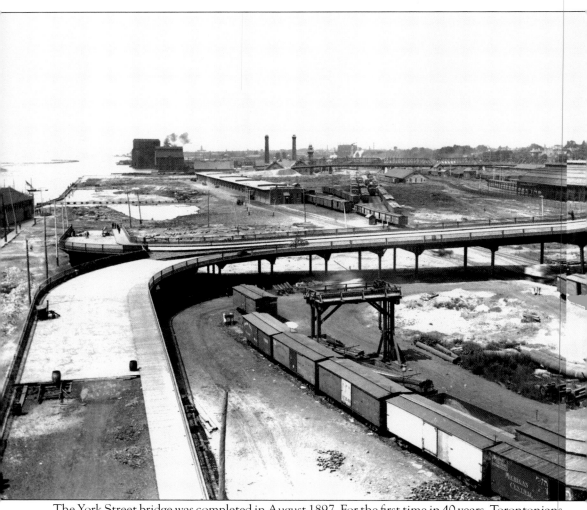

The York Street bridge was completed in August 1897. For the first time in 40 years, Torontonians could access the waterfront without having to dodge trains at level crossings. In the distance can be seen the John Street bridge that was completed around the same time. Both bridges were built by the railways as a quid pro quo to allow for the massive expansion of the rail yards that is evident here. To the right of the grain elevators in the distance is the new freight shed of the CPR. To the right of it is the CVR freight shed seen at the bottom of page 40. Shortly after

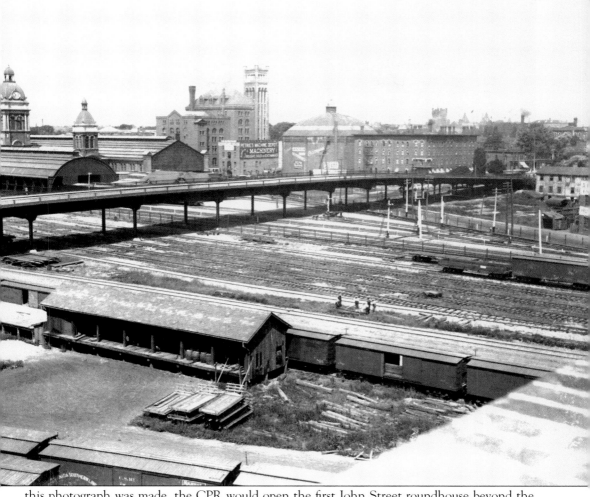

this photograph was made, the CPR would open the first John Street roundhouse beyond the sheds. Streetcar tracks were built on the York Street bridge, although they were never used. The lack of activity would suggest that this scene was photographed on a Sunday. In 1897 streetcars were allowed to operate in Toronto on Sunday for the first time, despite the opposition of many church groups. Important mainline trains operated daily, but most local passenger service in Ontario shut down on the Sabbath. (CTA, series 376, file 1, items 96 and 97.)

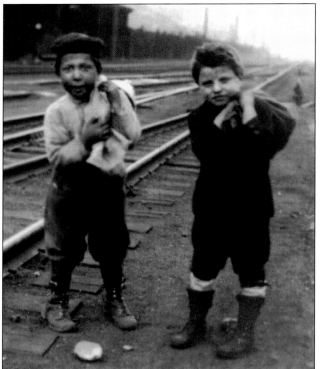

Around 1900 these two boys are gathering coal spilled along the railway tracks from passing trains. Poor children were encouraged in this dangerous endeavor by their parents, since the coal was needed to heat the family home during the winter. Many children were killed or injured by trains over the years since railway trespassing laws were virtually non-existent in that era. (OA, 10003835.)

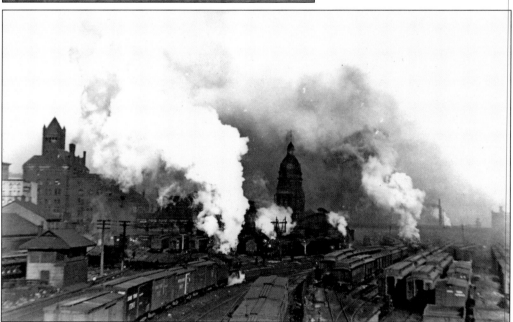

In an era when coal was the primary fuel, smoke and pollution envelope Union Station and obscure the skyline in this c. 1900 view from the John Street bridge. The small building on the left is Cabin C, a wooden interlocking tower built in the 1890s as part of the expansion of Union Station and replaced in 1931 by the current John Street tower. (NAC, PA200644.)

Three

INTO THE 20TH CENTURY

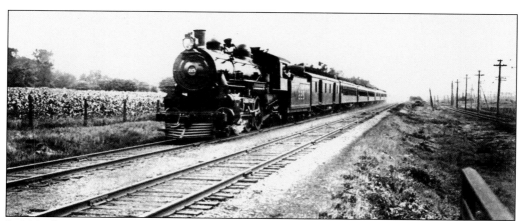

In 1900 the GTR inaugurated the *International Limited* between Montreal, Toronto, and Chicago. Covering the 878-mile trip in 23.5 hours, it was considered to be Canada's first true express train and quickly became the railway's flagship. The trip between Montreal and Toronto took 7.5 hours, making it the fastest train on the continent. Locomotives and trains were heavier and longer than just a few years earlier.

In 1901 the Canadian General Electric Company purchased 30 acres of land at Lansdowne Avenue and Davenport Road in the northwest part of Toronto and established the Canada Foundry to manufacture steam locomotives. Between 1904 and 1918 the Davenport Works produced 193 engines for the CPR, Canadian Government, Canadian Northern, Grand Trunk Pacific, and James Bay railways. The firm also manufactured railway bridges, turntables, and Bucyrus steam shovels.

In 1902 the GTR purchased the old Parliament Buildings on the north side of Front Street and built a freight yard and sheds, seen here looking west from Simcoe Street. For some time there was discussion of building a new Union Station on this site. The freight facilities remained until the 1960s, and the site is now occupied by Simcoe Place and the Canadian Broadcasting Corporation Broadcast Centre. (CSTM, CN 002863.)

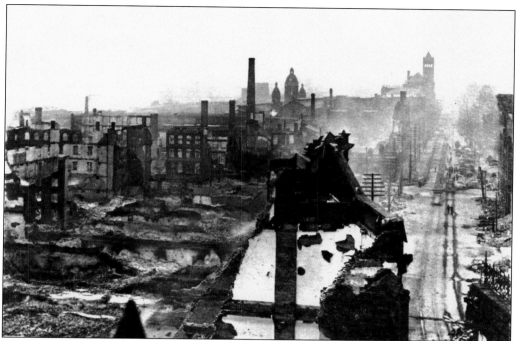

What became known as the Great Toronto Fire began on April 19, 1904, at a necktie factory near Wellington and Bay streets. By the time the conflagration was extinguished, 20 acres of Toronto's commercial and warehouse district were destroyed and 5000 people were out of work. One positive result was that the burned-out block east of the old Union Station provided a site for a new station. (TPL, T13275.)

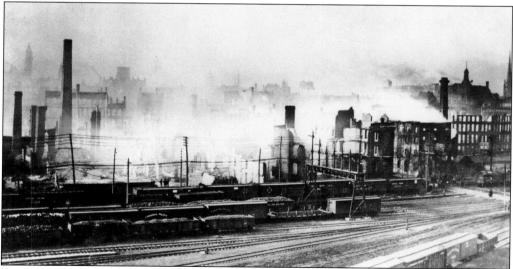

The fire still smolders behind the freight cars in this view looking northeast. On the far right can be seen the spires of the Board of Trade Building and St. James Cathedral, both untouched. The railways suffered little damage, and the authorities wasted no time trying to acquire the property seen here for a new Union Station, although it turned out that the city already owned much of it. (TPL, T13259.)

Photographs of the old Union Station interior are rare. This 1905 view looks west and shows the original 1873 train shed, which was heavily modified in the 1890s renovations. The elevated glass walkway comes in from Front Street and the waiting room on the right and through the station to the newer south train shed on the left. Station employees are loading baggage onto a CPR express car. (NAC, PA181479.)

This view shows the newer south train shed interior around 1908. The overhead walkway terminates at the platform between tracks 5 and 6. On the right, behind the official straddling the tracks, is the covered facade of the 1873 Union Station headhouse. A CPR train waits on track 3. The old Union Station was frequently overwhelmed by the huge amount of baggage carried by Torontonians. (CTA, fonds 1244, item 5040.)

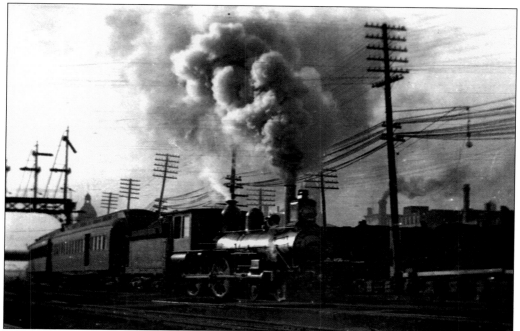

By 1907 there were 130 trains a day at Union Station, although many of them were short locals such as this GTR train rattling over the Bay Street crossing. The locomotive was an antique even then, having been built by the Manchester Locomotive Works in 1873. Many Torontonians were unhappy with what they perceived as the deteriorating level of local service provided by the GTR. (OA, 10002469.)

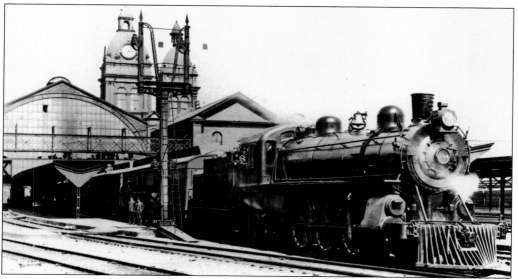

CPR 4-6-2 locomotive No. 1104 prepares to haul the *Muskoka Express* out of Union Station north to resort country in 1906. The engine was probably posed for this photograph shortly after its delivery from CPR's Angus Shops in Montreal. The slots in the smokestack were an early and unsuccessful attempt to prevent smoke from blocking the engineer's vision, a persistent problem in the age of steam. (NAC, PA149069.)

This sorry-looking work train is seen in the Don Valley during construction of the James Bay Railway in 1905. The GTR still owned the Belt Line, and a full-pitched battle between work crews erupted when the Canadian Northern attempted to cross over GTR tracks north of Bloor Street. At one point dynamite was brought into play and an explosion sent both sides running for cover.

The James Bay, renamed Canadian Northern Ontario Railway, made peace with the GTR and arranged to use the Belt Line from Rosedale south to the main line and into Union Station. Rosedale Junction is seen here in 1906 with the Belt Line climbing out of the valley on the left and the Canadian Northern on the right. Rosedale station was located behind the photographer. (CTA, fonds 1244, item 5005.)

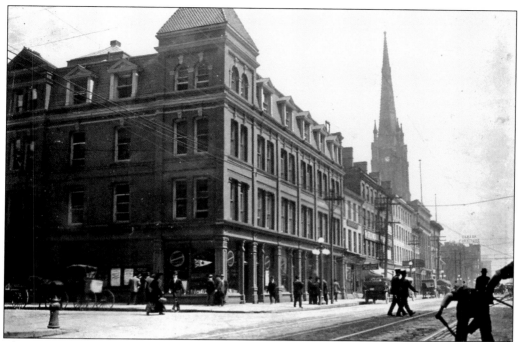

The Canadian Northern began operations between Parry Sound and Toronto in 1906. By 1914 the Canadian Northern was a transcontinental railway extending from Quebec City to Vancouver and maintained its headquarters in this modest building at King and Toronto streets. Canadian National headquarters were located here until 1923, when they were moved to Montreal. The steeple of St. James Cathedral is in the distance. (TPL, 2935.)

A Canadian Northern train climbs the grade on the freshly ballasted line underneath the CPR bridge north of Bloor Street near the Brick Works in 1907. As locomotives and trains became longer and heavier, CPR was obliged to replace the bridge with a more substantial structure in 1928. Today automobile commuters on the Bayview Extension drive underneath the bridge every day. (CTA, fonds 1244, item 5004.)

A Canadian Northern passenger train pulls into Rosedale station around 1912. The railway was the creation of two ambitious Torontonians, William Mackenzie and Donald Mann, both of whom were knighted in 1911. Mackenzie's house Benvenuto at Avenue Road and St. Clair is now the site of a luxury condominium. Mackenzie also controlled much of Toronto's streetcar system before it was taken over by the Toronto Transportation Commission in 1921.

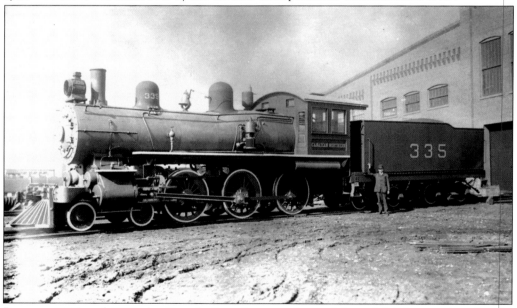

Between 1905 and 1907 the Canada Foundry manufactured forty 4-6-0 locomotives for the Canadian Northern Railway, the last of which is seen here outside the Davenport shops in October 1907. No. 335 hauled passenger trains through the Don Valley to and from Union Station. The engine was later acquired by Canadian National and was the last survivor of its class when it was scrapped in 1944.

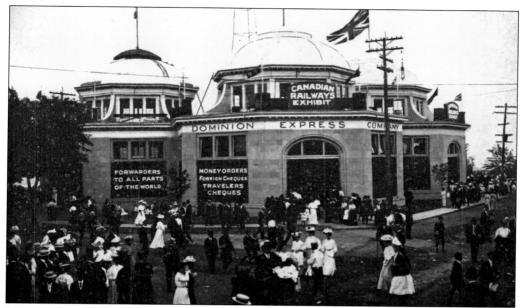

In 1907, the railways built their own display hall for the annual Toronto Industrial Exhibition, renamed the Canadian National Exhibition in 1912. The three domes of the Railways Building covered the pavilions of the CPR, GTR, and Canadian Northern Railway. For the next half-century, the railways used the building to promote their array of services, including railway travel, ships, hotels, cruises, resorts, and more mundane products like money orders.

A southbound CPR passenger train halts at the Don station in 1909. Don was built in 1896 as a convenience for passengers living in the expanding east end of Toronto. A Toronto Railway Company wooden streetcar crosses over the Queen Street bridge on the right. A year later, the bridge was rebuilt at a higher elevation, and the station was relocated 100 feet to the south. (TPL, MTL 2951.)

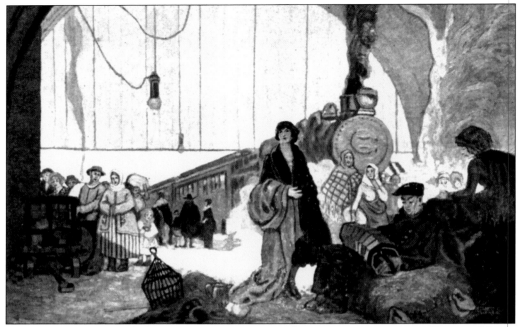

Stanley Turner painted this romantic impression of immigrants arriving at Toronto Union Station. Front and centre is a chic fashion plate draped with furs. In a nod to democratic ideals, she is surrounded by various ethnic representations, including a fellow playing his accordion. Which of them owns the birdcage is anybody's guess. The half-moon headlight on the locomotive is typical of the CPR.

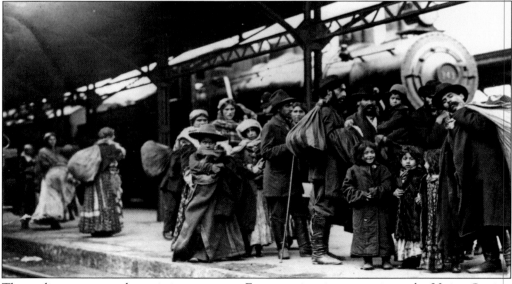

The reality was somewhat grittier as eastern European immigrants wait on the Union Station platform around 1910. It is not known if this group was changing trains while passing through Toronto or if they planned on settling in the city. Many established Torontonians did not welcome immigrants who appeared too "foreign," but the city's population more than doubled between 1900 and World War I. (NAC, C47042.)

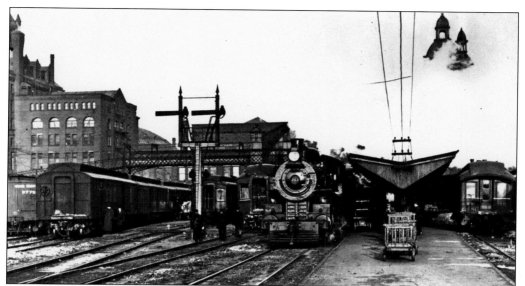

GTR 4-6-2 Pacific locomotive No. 203 prepares to haul a westbound passenger train out of Union Station in 1910. The steel footbridge on the left above the tracks was called the Bridge of Sighs because tens of thousands of immigrants between 1895 and 1923 wrestled their belongings from the train platforms over this structure to the corner of Front and Simcoe streets. (CTA, fonds 1244, item 100.)

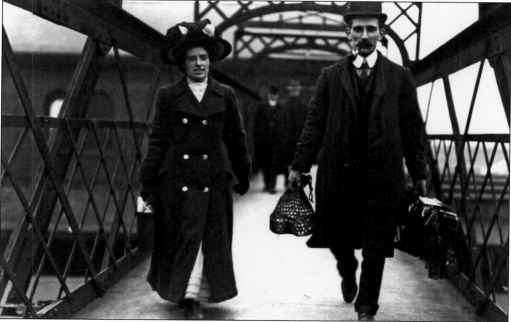

Toronto's Anglo-Saxon establishment preferred to welcome the British immigrants seen here on the Bridge of Sighs in 1911. The railway companies found immigration profitable and maintained offices in major European cities. Most immigrants traveled third class and paid about $30 for the transatlantic voyage on the numerous ocean liners that called at Halifax, St. John, Quebec City, or Montreal, depending on the time of year. (CTA, fonds 1244, item 103.)

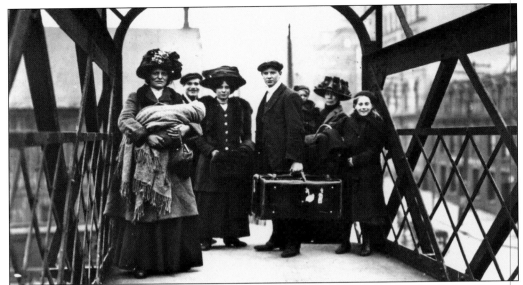

Another immigrant family poses on the Bridge of Sighs in 1911. Once they landed in Canada, immigrants proceeded to Toronto by train occupying colonist cars built for that purpose. CPR maintained its own fleet of ocean liners while the GTR promoted the ships of the White Star Line. The GTR's president perished on the maiden voyage of White Star's *Titanic* in 1912. (CTA, fonds 1244, item 102.)

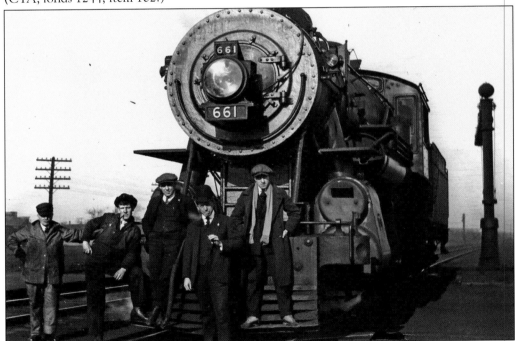

A century ago, a group of GTR employees posed in front of their 2-8-0 Consolidation freight locomotive at the Danforth Yard east of Toronto. Danforth was one of the GTR's principal Toronto freight yards; the other was in Mimico, west of the city. The steep grade east of the Don River that separated the two freight yards was a constant challenge for engine operating crews.

Four

GRADE SEPARATIONS AND A NEW UNION STATION

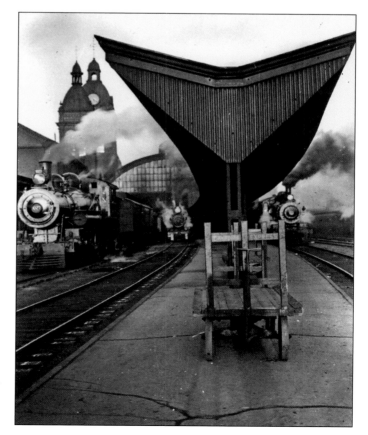

Artistic compositions of rail subjects were unusual in 1907, although the prolific photographer William James created this view of Union Station. It is also one of the most familiar train photographs ever seen since it is prominently displayed in the Skywalk and has been viewed by millions of people since 1989 on their way from Union Station to the Rogers Centre and the CN Tower. (CTA, fonds 1244, item 99.)

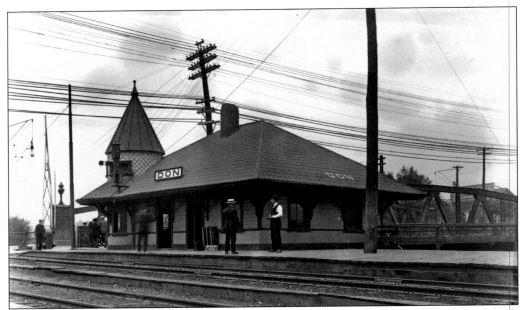

The Don station is seen in 1910, just before it was moved 100 feet to the south. Although built by the CPR, for most of its active service life Don was a "union" station, serving trains of the Canadian Northern, and later, Canadian National railways. The gentleman in his shirtsleeves is the station operator who worked in the room under the curved cupola. (CTA, fonds 1231, item 72.)

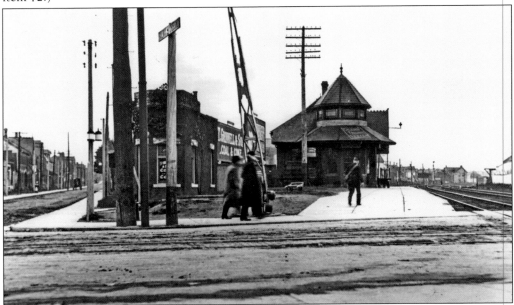

In 1896 the GTR opened a new station at Queen Street East (renamed Riverdale in 1907) for the convenience of passengers living in Toronto's expanding east end. In 1904 a freight train collided with a wooden streetcar here, killing 3 and injuring 17. The accident fueled the city's resolve that busy intersections between road and rail should be grade separated with subways or bridges. (CTA, fonds 1244, item 3589.)

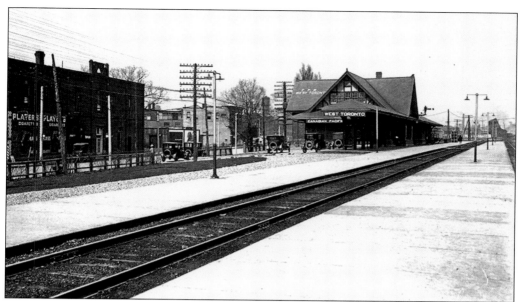

In 1911 the CPR built this mock Tudor station at West Toronto, an important rail junction with several significant industries, the stockyards, and major locomotive shops and freight yards. By the 1920s as many as 40 passenger trains a day stopped here. Despite efforts to preserve the station, CPR demolished it in 1982, and West Torontonians have been grieving its loss ever since. (Al Paterson.)

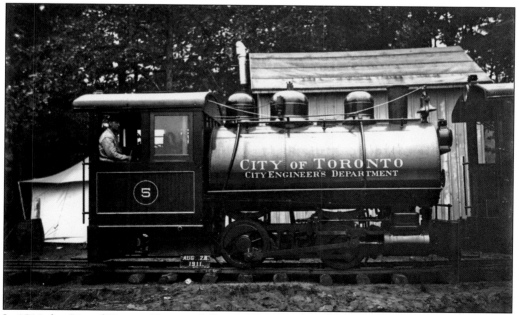

In 1911 the City of Toronto Engineer's Department purchased six saddle tank steam locomotives from the H. K. Porter Company to assist with heavy construction projects. Engine 5 is helping build the Toronto Civic Railways' Gerrard streetcar line in August 1911. Two steam shovels and 40 dump cars were also purchased. The equipment was sold after the Toronto Transportation Commission was established in 1921. (CTA, fonds 1231, item 1032.)

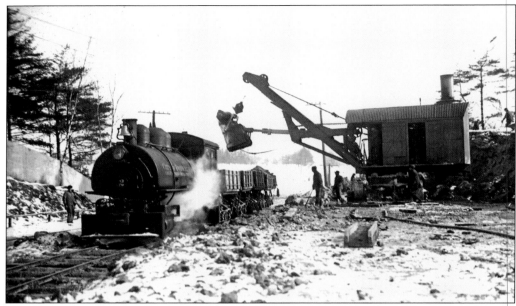

Two steam shovels were also purchased by the city. Engine 2 is seen here in 1912 building the St. Clair streetcar line east of Bathurst Street. The Toronto Railway Company, which operated the city's streetcar system until the Toronto Transportation Commission was created in 1921, refused to build into the rapidly expanding suburbs so the city established the Toronto Civic Railways to construct new lines. (CTA, fonds 1231, item 1045.)

In 1911 the Canadian Northern opened a new line from Todmorden east to Trenton, Ontario. The freshly ballasted track is seen here in Scarborough. By 1918 this line had been extended to Ottawa and Montreal. The redundant line through Scarborough was closed by Canadian National in 1926. Today this location is in Taylor Creek Park and a Hydro corridor follows the right-of-way. (CTA, fonds 1244, item 5008.)

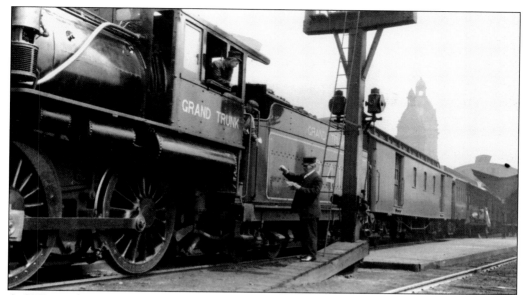

A GTR conductor reads the train orders out loud while the locomotive engineer follows along on his copy and the fireman looks on. The conductor is standing on an interlocking mechanism used to operate the track switches and signal lights governing train movements around Union Station in this 1915 view looking east. (NAC, PA61436.)

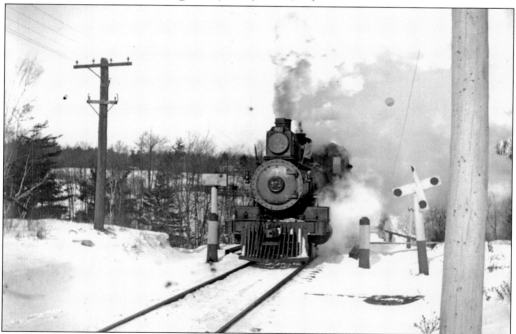

Canadian Pacific 4-6-0 No. 572 leads a passenger train off the bridge in the Don Valley near Rosedale. A clearer view of the bridge can be seen on page 65. Building the CPR's Don Branch between Leaside and Union Station took five years between 1888 and 1893. There were numerous engineering obstacles to overcome, including steep grades and five substantial new bridges. (OA, 10002462.)

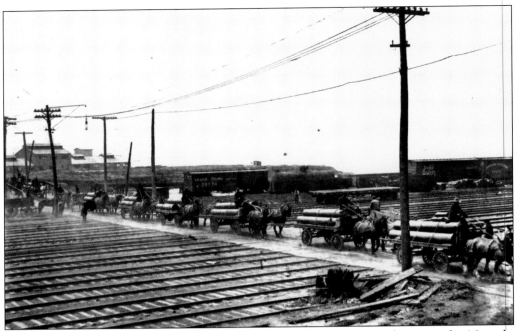

The first steel pipe of the National Iron Works, seen in the distance, rattles across the 16 tracks at the Cherry Street level crossing. Presumably arrangements were made to halt rail traffic while this procession was underway. In the 1850s Toronto's leading architects had competed to design the Esplanade as a citizens' waterfront promenade. This is what the Esplanade had come to 60 years later. (CTA, fonds 1244, item 121.)

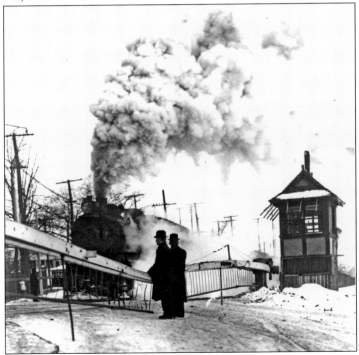

A GTR train roars over the Lakeshore Road crossing at Sunnyside in the winter of 1911. A mile west of here was the worst railway accident in Toronto's history. On January 2, 1884, two GTR trains collided in a blinding snowstorm south of High Park near Grenadier Pond, with a loss of 31 lives. Today there is not even a plaque commemorating the event. (CTA, fonds 1244, item 5054.)

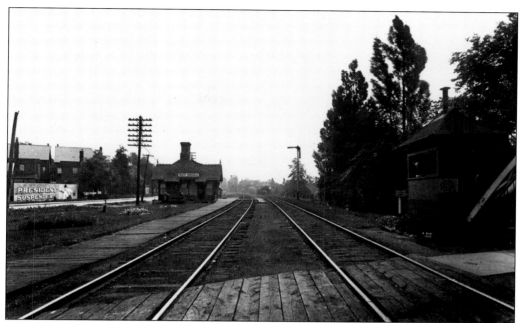

This pastoral view looks east from Jameson Avenue in August 1910. The old GWS South Parkdale station is on the north side of the tracks. The crossing guard in the wooden shelter appears quite interested in the photographer; perhaps he is fretting over a scheduled train due to arrive soon. This bucolic scene would soon be disturbed for the massive Parkdale grade separation project. (CTA, fonds 1231, item 215.)

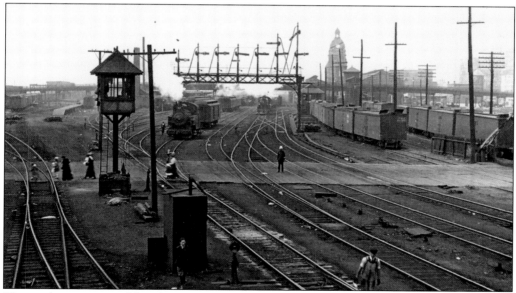

The grade crossing problem became so acute that the city assigned police to guard the busier crossings. This 1914 scene is looking west from Bay Street as some women and children are rushing for one of the island ferries. On the left is an elevated guardhouse used by employees operating the crossing gates across the road. One of these structures has been restored at the Toronto Railway Heritage Centre.

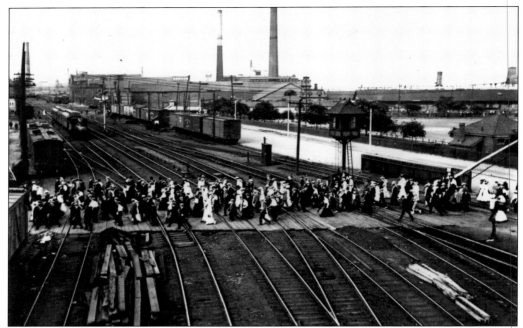

Crowds stream across the tracks at Bay Street while a passenger train on the left waits for the gates to be lowered in this 1912 scene looking east. The chimney marks the Scott Street steam generating plant of the Toronto Electric Light Company. The open space on the top right is Bayside Park, obliterated when the waterfront grade separation was built in the 1920s. (CTA, fonds 1244, item 1089.)

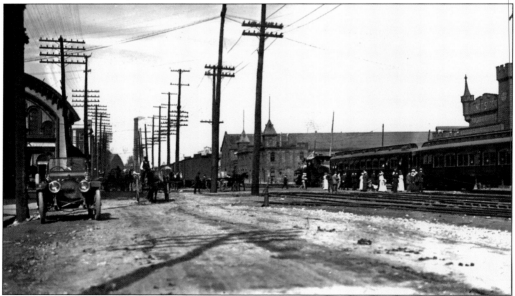

Pedestrians at the Yonge Street crossing on their way to the castellated steamship docks seen behind the train find their way blocked by CPR 0-6-0 locomotive No. 6210 switching passenger cars on the eastern approach to Union Station. The dirt road on the left was what remained of the Esplanade. Behind the automobile is the old GWR passenger station. (CTA, fonds 1231, item 1384.)

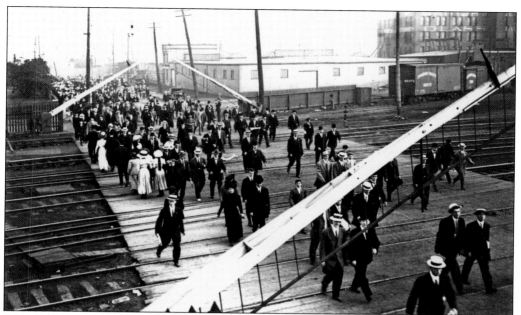

This 1911 view is looking south at the Bay Street crossing while a crowd streams north from the ferry docks on a summer weekend. Every male in this photograph is wearing a suit, tie, and hat. When impatient pedestrians found the crossing blocked by parked trains, they would often crawl under or between the cars, with predictably tragic results when the trains suddenly began moving. (CTA, fonds 1244, item 259e.)

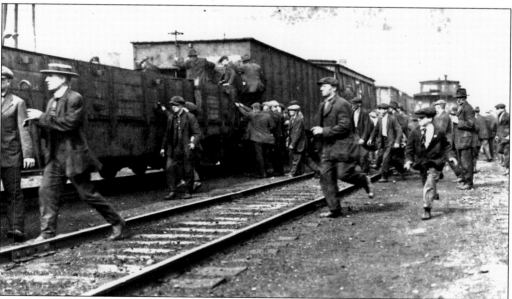

In 1911 at the foot of Spadina Avenue, factory and warehouse workers climb over a parked freight train in order to get to work on time. Hundreds of people were killed or injured over the years attempting this, a major factor in the pressure for a grade-separated railway corridor along the waterfront. Impatient commuters looking for shortcuts have long compromised railway safety protocols. (CTA, fonds 1244, item 108.)

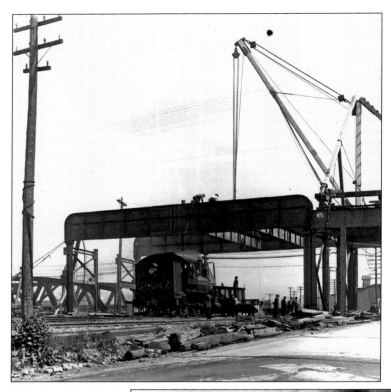

The Don station was moved to accommodate the building of a new high-level bridge to carry Queen Street over the Don River and avoid the level crossing of the railway tracks on this increasingly busy route. By 1911 there were 22 passenger trains a day stopping at Don as well as numerous CPR and Canadian Northern freight trains passing through. (CTA, fonds 1231, item 1053.)

Between 1910 and 1930, there were four massive construction projects in Toronto where level crossings between road and rail were grade separated. The first of these was the Parkdale grade separation initiated by the GTR in 1910. Here a huge steam shovel digs up the ground near High Park for the new right-of-way. The existing two-track route can be seen on the upper right.

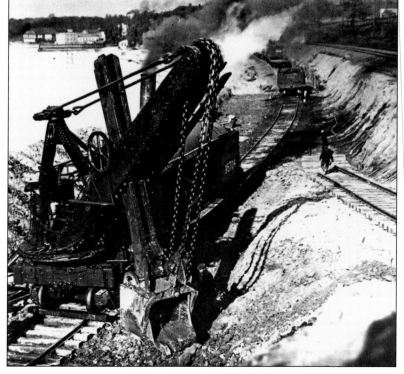

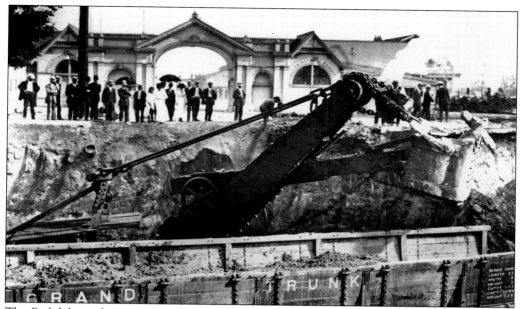

The Parkdale grade separation eliminated 13 grade crossings by building four bridges and nine underpasses along the six-mile GTR right-of-way between Strachan Avenue in the east and Mimico in the west. In an era when safety regulations were considerably less stringent, a crowd of sidewalk superintendents observes a steam shovel at work in front of the Canadian National Exhibition Dufferin Gates. (CTA, fonds 1244, item 5017.)

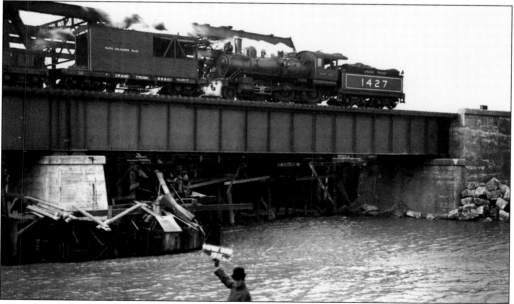

The photographer's assistant with his information board dates this 1911 view of the GTR bridges over the Humber River. The new four-track right-of-way required two new bridges over the Humber to supplement the older bridges seen behind the train. The Humber and the Don are Toronto's two largest rivers, and the bridges over them were occasionally upgraded to accommodate heavier trains. (CTA, fonds 1231, item 863.)

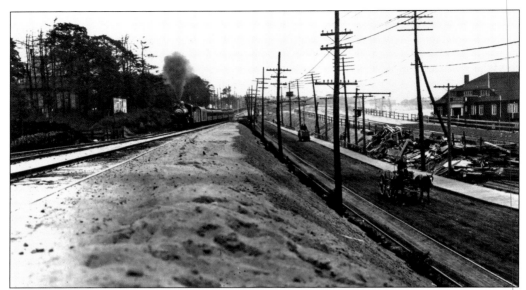

This 1913 view looking east from High Park shows the first GTR passenger train to travel over the newly elevated tracks of the Parkdale grade separation. The building on the right is the Parkdale Canoe Club, which was destroyed by fire shortly after this photograph was taken. Sunnyside Amusement Park opened on this site in 1922. (CTA, fonds 1244, item 1467.)

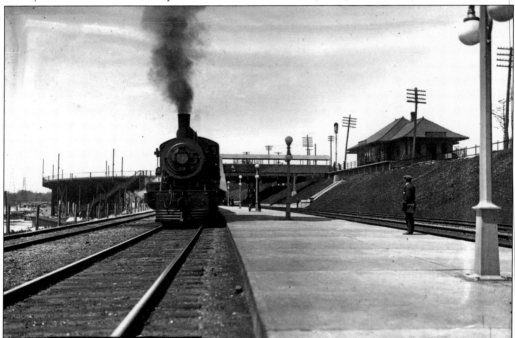

A GTR passenger train pauses at Sunnyside in 1915 before completing its journey to Union Station, three and a half miles to the east. Sunnyside was built in 1912 as a convenience for west end passengers and was shared with CPR trains. In 1967 GO Transit declined to stop here and the station was demolished, although the tracks still bow out to accommodate the long-gone platform. (CTA, fonds 1231, item 1041.)

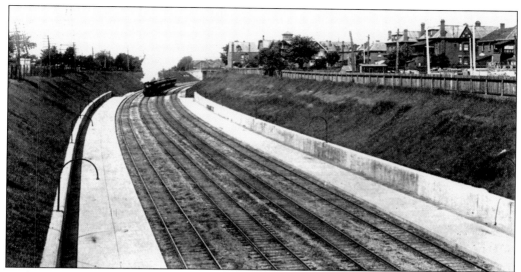

With the completion of the Parkdale grade separation in 1913, the GTR owned one of the most superbly engineered railway rights-of-way in Canada. The entire project was supervised by John Ambrose, who went on to organize the building of the waterfront grade separation and the new Union Station. This view is looking west from the Dufferin Street bridge and shows the new Exhibition station built as a convenience for fairgoers.

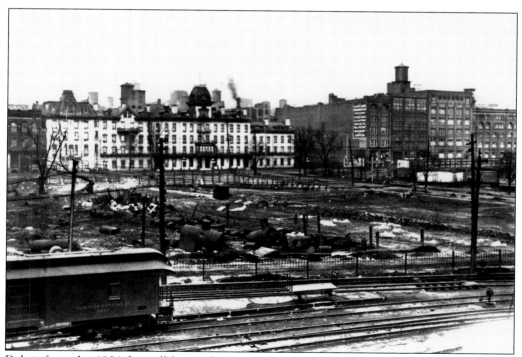

Debris from the 1904 fire still litters the site of the future Union Station in this c. 1912 view looking north toward Front Street. The wooden car in the foreground is lettered for the Dominion Express Company, owned by the CPR and renamed CP Express in 1926. The white building on the north side of Front Street is the Queen's Hotel. (CTA, fonds 1244, item 8221.)

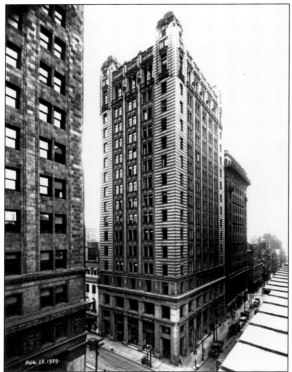

With company offices scattered all over downtown Toronto, the CPR built its own skyscraper in the banking district at King and Yonge streets. The building was the tallest in the city when it opened in 1913. The ground floor City Ticket Office was magnificently paneled in marble. The building is still there, although the marble paneling was torn out around 1990 to accommodate a drugstore. (CTA, SC639A, item 1.)

In an era before one could conveniently order train tickets over the telephone or the Internet by using a credit card, the railways maintained downtown ticket offices as a convenience for their customers who worked nearby, particularly the first-class passengers who were employed in Toronto's financial district. This GTR ticket office was located at King and Yonge streets, across from the CPR building.

The second massive grade separation project in Toronto was along CPR's North Toronto subdivision between Summerhill Avenue, just east of Yonge Street and Dufferin Street. Ten subways were built along the three-mile right-of-way so that major streets could pass under the elevated tracks. This November 1913 view is looking west along Cottingham Street toward the new elevation. North Toronto Station is on the left. (CTA, fonds 1231, item 1072.)

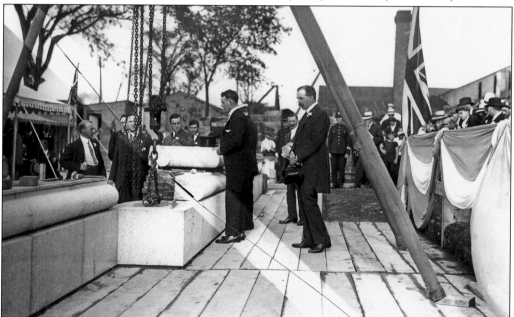

The North Toronto grade separation also involved the building of a new passenger station to replace the original 1884 station (seen above). On September 9, 1915, Toronto mayor Thomas L. Church officially laid the cornerstone of the station. The facility was intended to be shared with the Canadian Northern, but the financially strapped railway dropped out by the time the station was completed. (CTA, series 372, subseries 46, item 128.)

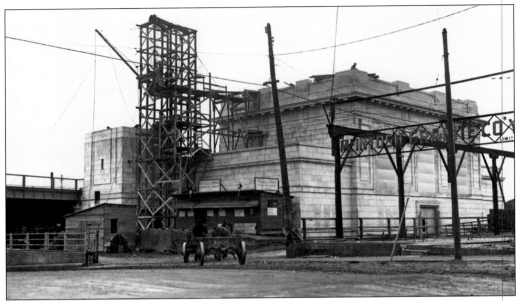

North Toronto Station was built by the P. Lyall & Sons Construction Company at the same time the company began work on Union Station. The Beaux-Arts building was clad in beige Tyndall limestone from Manitoba. The CPR was frustrated with the interminable negotiations over the new Union Station and planned on moving several of its trains from the downtown terminal to North Toronto. (CTA, series 372, subseries 46, item 136.)

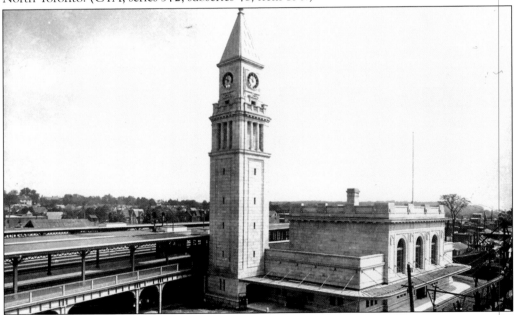

Toronto architects Darling & Pearson designed North Toronto Station following their successful execution of the downtown CPR building. The most distinctive feature of the new station was the 140-foot clock tower, based on the Campanile of St. Mark's in Venice, Italy. The tower's illuminated clock was synchronized daily by a telegraph signal sent from the master clock located at CPR headquarters at Windsor Station in Montreal. (TPL, MTL 2973.)

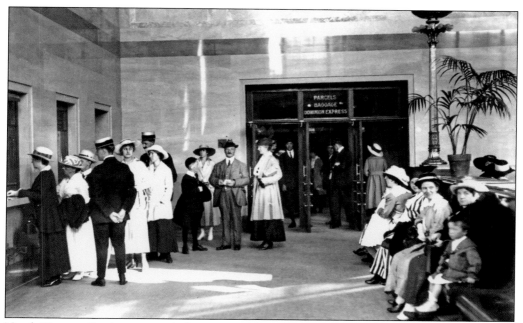

North Toronto Station was ready for service in June 1916, and by July CPR had shifted 20 trains a day into the new facility. This photograph was made shortly after the station opened and only shows a corner of the magnificent three-storey-high, 70-by-51-foot waiting room. The doorway leads to a tunnel under the tracks with staircases ascending to the platforms overhead. (CTA, fonds 1244, item 930.)

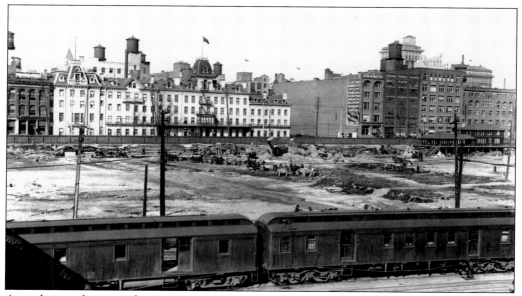

A modest work crew is beginning construction on Union Station in this October 1915 scene looking north toward Front Street. Torontonians were less than impressed with the size of the work crew engaged in construction due to wartime manpower shortages. On the left is a baggage car with wide doors to accommodate trunks; on the right is a mail service/express car with narrower doors. (CTA, fonds 1231, item 1108.)

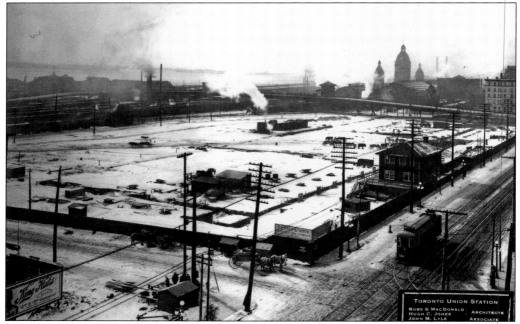

This December 31, 1915, view looks southwest from the corner of Front and Bay streets. In two months since the previous image, there has been little visible progress. The wooden building facing Front Street houses the construction offices of the building contractors P. Lyall & Sons, who built some of Canada's most recognizable structures, including the Parliament Buildings in Ottawa. (CTA, fonds 1172, series 2, item 98.)

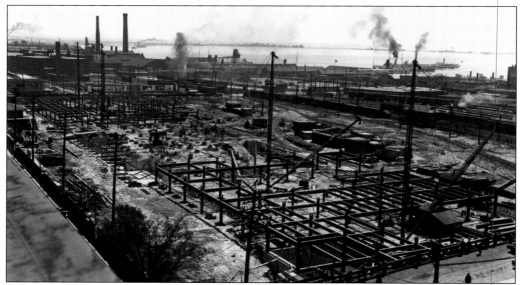

By May 1916 the steel framework for Union Station is well underway in this image looking southeast from Front and York streets. Some 5900 tons of structural steel were provided by the Canadian Bridge Company of Walkerville, Ontario. The west wing was occupied by railway offices in 1920, and the tradition continued 90 years later when it was purchased by GO Transit for its new headquarters. (CTA, fonds 1231, item 902.)

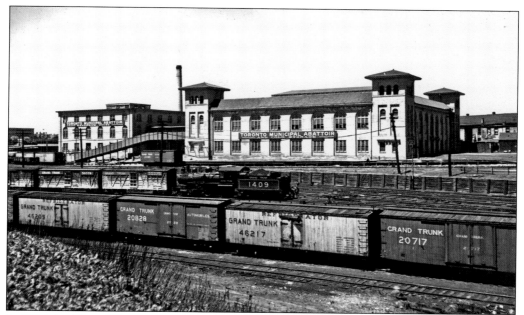

In 1914 the City of Toronto was concerned about sanitary conditions at private slaughterhouses and opened the municipal abattoir across from Fort York. Meatpacking was a major industry in Toronto, with the livestock transported in the slatted cars in front of the locomotive while the dressed meat was delivered in the refrigerated cars in the foreground. The building survives today, although it is unrecognizable. (CTA, fonds 1231, item 513.)

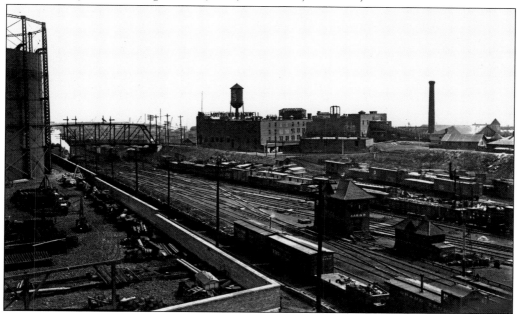

This 1916 view looks southeast toward the Bathurst Street bridge. On the upper right are the ramparts of Fort York. Cabin D on the lower right was an interlocking tower built in 1896 to control the track switches west of Spadina Avenue. The cabin remained in operation until 1983 and was restored in 2009 at the Toronto Railway Heritage Centre. (CTA, fonds 1231, item 1044.)

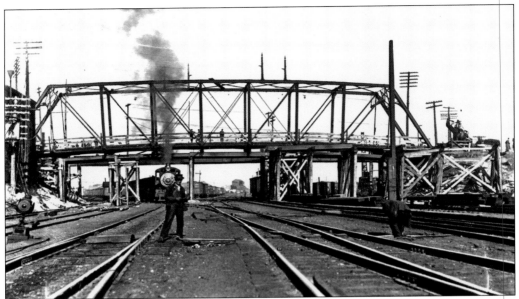

The old Bathurst Street bridge is seen here in 1916, just before it was replaced by the sturdier span that is still in use almost a century later. The two employees are switch tenders, whose job it was to throw the track switches according to instructions issued from the train movement director in Cabin D. Amazingly this manual system of operation remained in place until 1983. (CTA, fonds 1231, item 1921.)

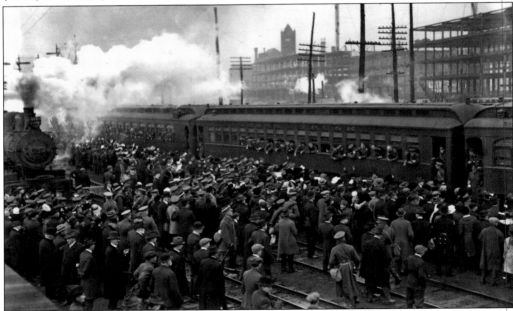

Well-wishers crowd the train yards near Bay Street in 1916 to see off departing members of the Canadian Expeditionary Force while a CPR switching locomotive simmers on the left. World War I placed extraordinary demands on the railways, which were forced to improvise since the old Union Station could not handle these crowds. The steel framework of the new Union Station rises behind the coaches. (CTA, fonds 1244, item 821.)

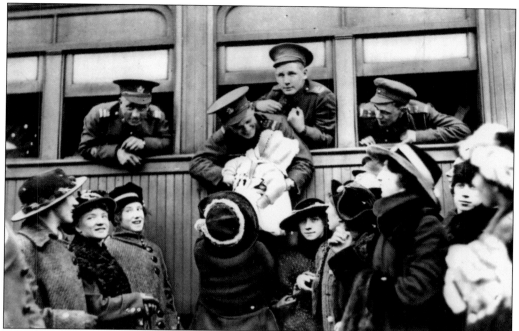

Most of the soldiers departing by train from Toronto traveled first to Camp Borden near Barrie or to Valcartier in Quebec before being shipped off to Europe. Despite the seemingly happy countenances seen here, Toronto's sacrifice in World War I would prove to be appalling. Of the approximately 60 000 Torontonians who fought in the Great War, 10 000 were killed and 20 000 wounded. (CTA, fonds 1244, item 824.)

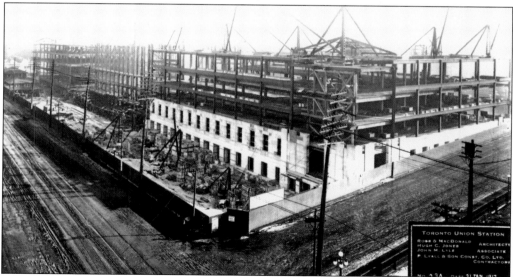

On January 31, 1917, Union Station's limestone cladding is being attached to the steel frame. Some 17 000 tons of limestone were imported from Indiana and cut and finished in Sarnia, Ontario, so as to avoid paying customs duty on the dressed stone. The condition of the roads lends credence to Toronto's long-standing denigration as Muddy York. (CTA, fonds 1172, series 2, item 71.)

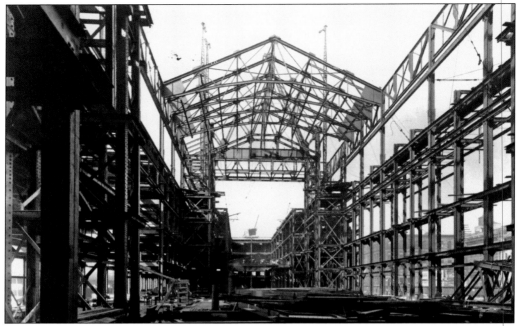

The steel framework of the Ticket Lobby, now known as the Great Hall, occupies the centre of this April 12, 1917, view looking west from Bay Street. Construction of Union Station was constantly delayed throughout the war with shortages of financing, building materials, and skilled tradesmen, most of whom had been drafted into the military. (CTA, SC172-2-66.)

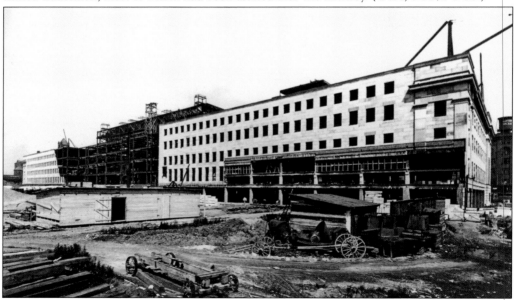

The east wing of Union Station is under construction in this July 1917 view looking northwest from where the train shed would be built a decade later. This wing was occupied by the post office in 1920, when most intercity mail was carried by train. The post office moved out in the 1970s, and this wing is now occupied by Scotiabank, although the ground floor will soon become public space. (CTA, fonds 1172-2-62.)

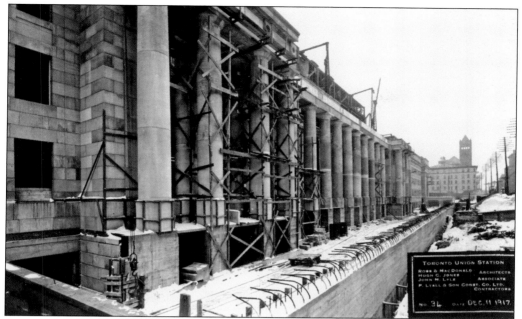

Among the most impressive features of Union Station are the 22 limestone Doric columns facing Front Street, each 40 feet in height and weighing 75 tons. The columns were turned on the largest lathe in North America, built especially for this purpose in Sarnia. The concrete tunnel in this December 1917 view houses the driveway, and the pedestrian Front Street plaza was later built on top of it. (CTA, fonds 1172-2-49.)

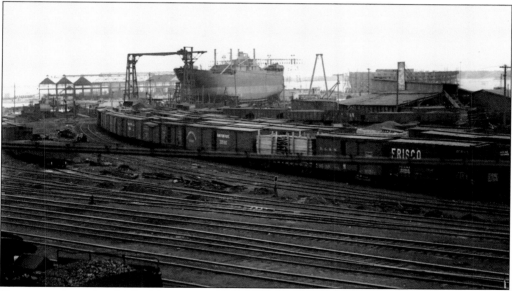

Toronto was a major shipbuilding centre in the early 20th century, with most of the components brought into the city by rail. This is the Thor Iron Works near the foot of Bathurst Street around 1918. The ship under construction is the freighter *Troja*. These shipyards disappeared in the 1920s, when the Harbour Commission reclaimed the land and the shoreline was moved farther south. (CTA, fonds 1244, item 862.)

The 48th Highlanders detrain at the Exhibition station around 1918. The regiment is a significant part of Toronto's military history. During the war, the government used the Canadian National Exhibition grounds as a military camp and demobilization centre. The station, a substantial set of concrete platforms located just west of Dufferin Street, was abandoned in 1967 but is still in place. (CTA, fonds 1244, item 814.)

The Canadian Northern Rosedale yard is seen in this 1918 view from the Bloor Street Viaduct, then under construction, while a freight train climbs the grade on the lower left. The railway has placed lines of freight cars around the yard to help stabilize the track during the annual flooding. The Brick Works and CPR bridge can be seen on the upper right. (CTA, fonds 1244, item 1280.)

On April 4, 1919, the scaffolding was still in place to install the barrel-vaulted ceiling decorated with coffered Gustavino tiles. The ceiling is 88 feet above the floor of the Ticket Lobby and suspended from the roof by steel bars. The tiles, which are thin and reflect light, are laid in a herringbone pattern to reflect the pattern of the marble tiles on the floor below. (CTA, SC 172-2-21.)

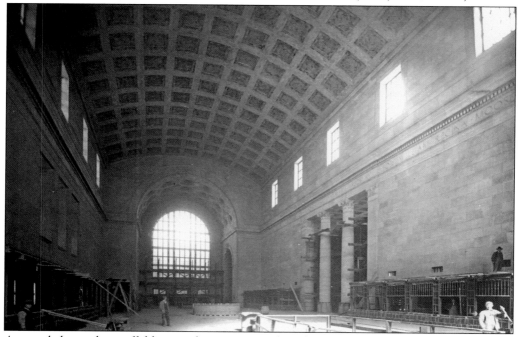

A month later, the scaffolding is almost gone and workmen finish the interior of the Ticket Lobby. The tickets that gave the room its name were sold at the counters on the left. Right of centre is the parcel checking room while the structure on the far right housed the baggage check-in counter, now the VIA Rail ticket windows. (CTA, fonds 1172, series 2, item 19.)

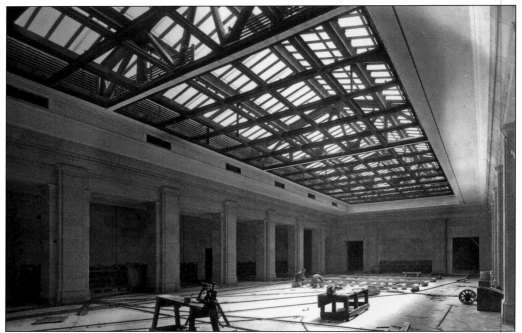

The Waiting Room, seen here in May 1919, was on the ground floor of the west wing. The room was away from the bustle of the main station and furnished with large wooden benches for waiting passengers. The Oak Room restaurant was through the doorways on the right. The overhead skylight was covered up in World War II and restored by the City of Toronto in 2006. (CTA, SC 172-2-20.)

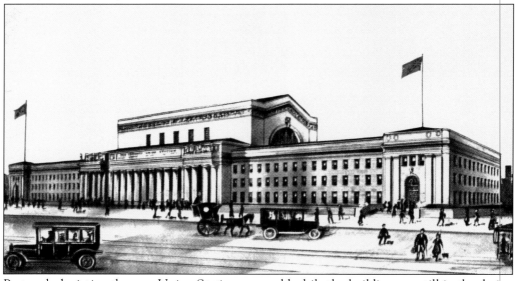

Postcards depicting the new Union Station were sold while the building was still in the design stage. In this rendering the clerestory roof defining the ticket lobby was taller than built. Although barely discernible here above the columns, planned sculpture groups of famous railway pioneers were eliminated from the project. One can only imagine the political machinations involved in deciding who might have been included in these groupings.

Five

THE ROARING TWENTIES

As the city expanded throughout the 1920s into what were remote suburbs just a few years earlier, road crossings became much busier and the pressure was on to build additional grade-separated underpasses. Even in the 21st century, as rail lines become more congested with commuter traffic, communities all over the Greater Toronto area lobby their government to build more railway underpasses. (CTA, fonds 1244, item 1155.)

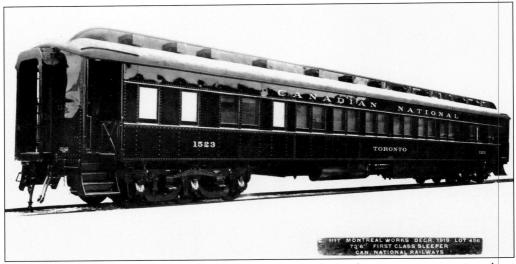

First-class passenger cars were usually assigned names, often referencing communities along the line, rather than the plain numbers that adorned more plebeian coaches. The *Toronto* was a 12-section, 1–drawing room sleeper ordered by the Canadian Northern but delivered to Canadian National in 1919. In the first half of the 20th century, there were thousands of these types of sleeping cars in use throughout North America. (Dale Wilson.)

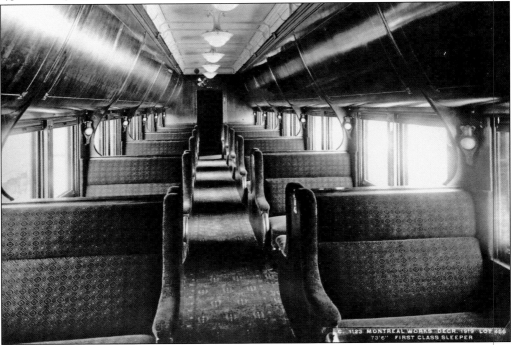

The interior of the *Toronto* shows the open section arrangement during the day. At night the facing seats were converted into a lower berth while a less expensive upper berth folded down from above. Heavy curtains provided some privacy, but for well-heeled passengers, a private and completely enclosed drawing room was available behind the photographer for about three times the cost of a berth. (Dale Wilson.)

A century ago, the ultimate status symbol was a private railway car. In this *c.* 1920 view, Sir John Craig Eaton (right) enjoys the companionship of his wife and relatives on the *Eatonia*. The T. Eaton Company, based in Toronto, was the largest retailer in Canada and had established a successful catalog business in 1884. The efficient delivery of merchandise throughout Canada was made possible by a national railway network.

The department store magnate would have easily acquired sumptuous furnishings with which to fill the *Eatonia*. This is the master stateroom. Personal needs were attended to by two stewards who accompanied the car everywhere. Sir John was a CPR board member, and he contracted the flu that would kill him at age 46 while attending a board meeting in Montreal in 1922.

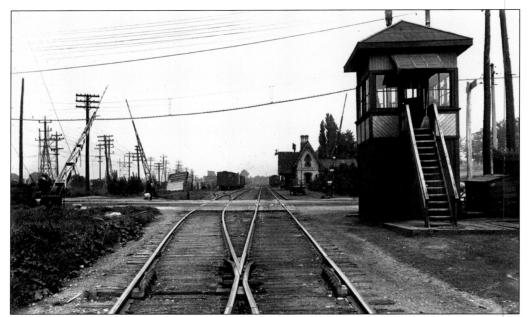

Toronto grade crossings used to be dotted with hundreds of these structures that housed crossing guards who operated the gates and turned the nearby track switches. This one was located at Davenport Road south of the old NRC station built in 1863 and replaced by St. Clair Station in 1931. One of these guardhouses has been restored by the Toronto Railway Heritage Centre. (CTA, fonds 1231, item 1086.)

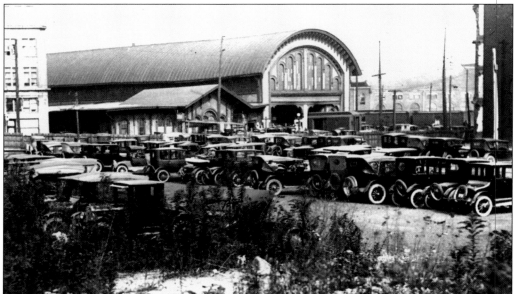

The old 1866 GWR Yonge Street station is still intact in the 1920s, when it was being used as Toronto's wholesale fruit terminal. The structure was destroyed by fire in 1952, and the Sony Centre now occupies the site. The vacant lot in the foreground is now the Dominion Public Building, and the Union Station GO bus terminal occupies the parking lot. (CTA, fonds 1244, item 2505.)

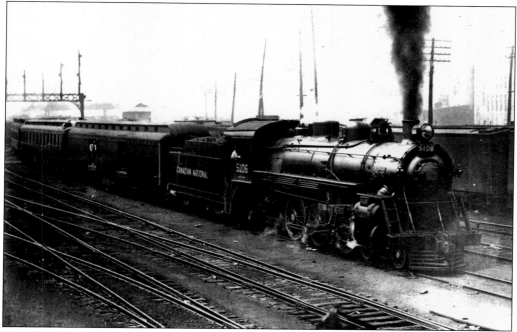

Canadian National Railways was formed in 1919 by the federal government to rescue a group of financially floundering railways that included the Canadian Northern and GTR. Canadian National's first priority was to upgrade the worn-out trains and facilities inherited from its constituents. Here the inaugural eastbound *Capital City* departs Union Station for Ottawa on June 28, 1920; the westbound train was known as the *Queen City*. (Al Paterson.)

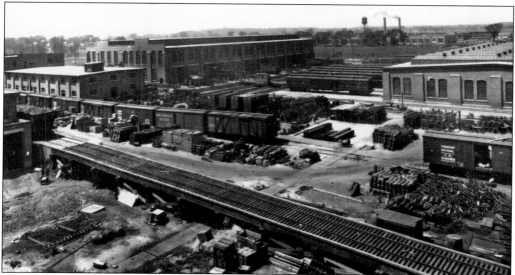

During World War I, the Canadian Northern Railway began building a new Eastern Lines terminal at Leaside where it also planned a large residential suburb. Following the demise of the Canadian Northern, Canadian National finished the terminal, seen here in the early 1920s. A transfer table separates the locomotive shops on the left and the passenger car shops on the right. The engine shop building still survives. (CSTM, CN003958.)

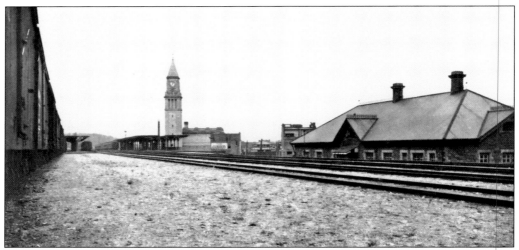

The old and new North Toronto stations are seen in this 1920 view looking east. The city bought the old 1884 station and set up a farmers' market, but this was unsuccessful and the building was demolished in the 1920s. The most popular train to use the new station was the overnight to Montreal, patronized by well-heeled businessmen living in Toronto's prosperous north end. (CTA, fonds 1244, item 1748.)

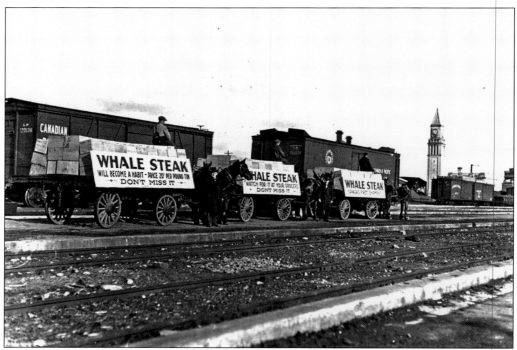

This 1919 view is from the freight yard on Marlborough Avenue west of Yonge Street toward North Toronto Station. Wartime inflation had ravaged the budgets of many households, and this marketing scheme was an unsuccessful attempt to sell canned whale meat as an inexpensive alternative to beef. One can only imagine the reaction today from environmental groups to such a venture. (CTA, fonds 1244, item 1939.)

In 1897 the CPR built a roundhouse at the foot of John Street, extended south by the new bridge over the tracks. This facility replaced the roundhouse at Parkdale inherited from the CVR. The roundhouse was continually expanded and is seen here in 1921 looking north toward the John Street bridge. Today the Rogers Centre occupies the site on the left. (CTA, fonds 1231, item 2146.)

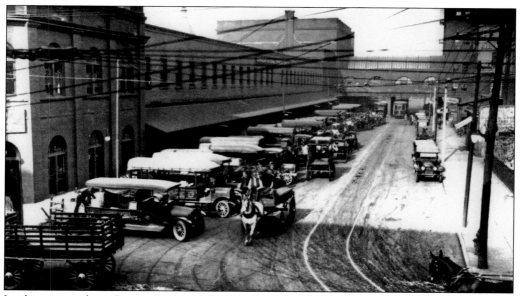

Looking west along Station Street in 1923, a Toronto Transportation Commission 2300-series Peter Witt streetcar boards passengers underneath the old Union Station arcade. The Canadian Express Company had just been taken over by Canadian National and is doing a brisk business. The square structure at centre top encloses the Union Station Waiting Room. A photograph of it being demolished is on page 121.

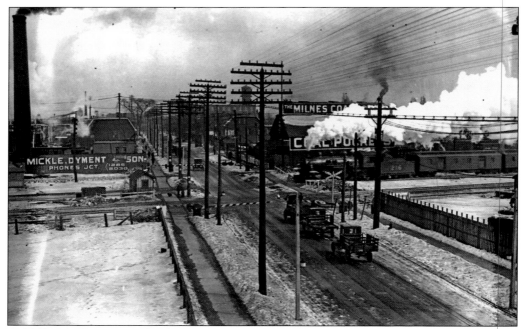

A GTR 4-6-2 locomotive hauls a passenger train toward Union Station in this 1920 image of the same Bloor Street West level crossing seen on page 97. The city and the railways collaborated on the Northwest grade separation project in the late 1920s, the last of the four vast grade separations of the early 20th century. (CTA, fonds 1266, item 216.)

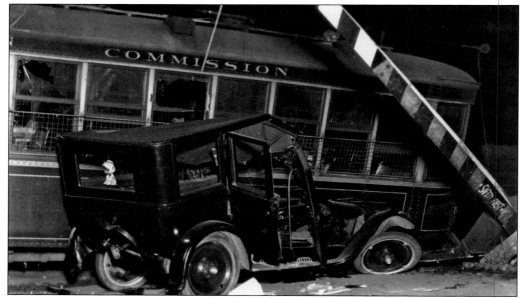

On September 11, 1926, four runaway Canadian National freight cars crashed into a Toronto Transportation Commission streetcar at the Queen Street East crossing near Riverdale station. This was the same location as the fatal 1904 collision between a train and a wooden streetcar. Construction of the new Queen Street subway was scheduled to begin two days after the accident as part of the new waterfront grade separation. (CTA, fonds 1266, item 8780.)

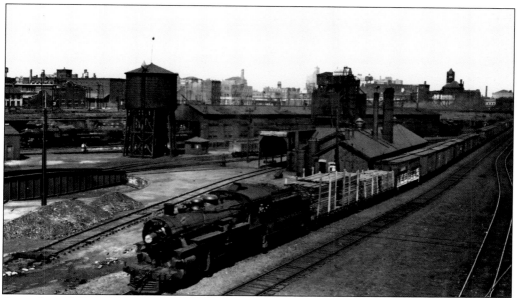

A westbound Canadian National freight train prepares to duck under the Spadina bridge. Both steam locomotives seen in this view were inherited from Canadian National's predecessor railways, the 2-8-0 consolidation in the foreground from Canadian Government Railways and the 0-6-0 switcher on the upper left from the GTR. The GTR also built the 250-foot Long Shop seen to the right of the water tower. (Al Paterson.)

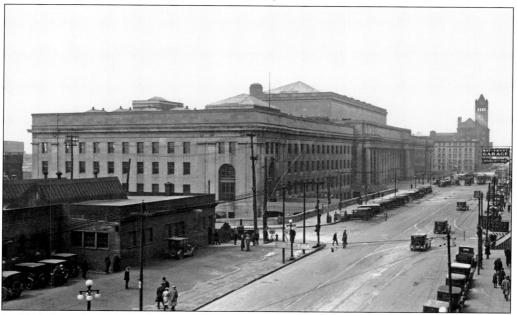

In 1923 the railways hosted an open house so Torontonians could view the interior of the new Union Station that was a prominent landmark along Front Street but had been shuttered since 1920. Uniformed attendants conducted 4000 visitors through the station on the first day, a failed public relations attempt that only infuriated the public once they saw the splendors that were being denied them. (CTA, fonds 1231, item 70.)

Handling Canada's Commerce

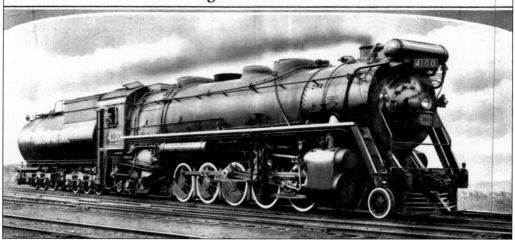

In 1924 Canadian National ordered five 2-10-2 Santa Fe locomotives from the Canadian Locomotive Company in Kingston, Ontario. Numbered 4100 to 4104, these were then the largest and most powerful locomotives to operate in Canada and were used to haul heavy freight trains up the steep grade from the Don River to Scarborough. No. 4100 has been preserved at the Canadian Railway Museum near Montreal.

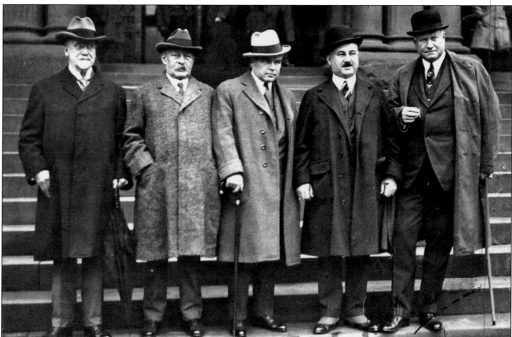

In 1923 senior officials posed for photographers on the steps of Toronto City Hall after meeting to discuss the moribund waterfront grade separation. On the right is Canadian National President Sir Henry Thornton; beside him is Mayor Charles McGuire; in the middle is CPR President Edward Beatty. Despite the involvement of the chief executive officers, discussions dragged on for another year and construction did not begin until 1925. (TPL, T32384.)

The problem with North Toronto Station is illustrated in this 1920s photograph where the facility appears deserted. Many passengers transferred to other trains downtown, entailing a long streetcar ride along an increasingly congested Yonge Street. After Union Station opened in 1927, business at North Toronto declined precipitously and the station was closed in 1930. The building was beautifully restored in 2003 and now houses a liquor store. (OA, 10001308.)

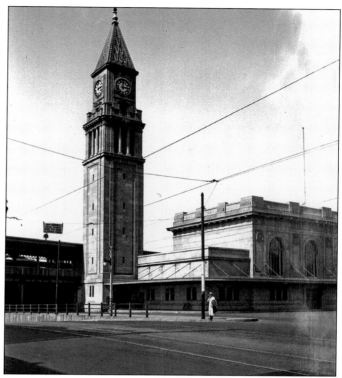

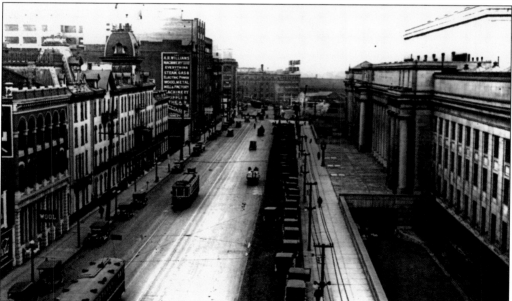

Union Station also appears deserted in this mid-1920s view looking east along Front Street. Although railway offices had occupied the west wing and the post office had occupied the east wing in 1920, the centre block housing the actual passenger station sat empty while the railways, the Harbour Commission, and the city argued about how the tracks were going to access the facility. (CTA, fonds 1244, item 1006.)

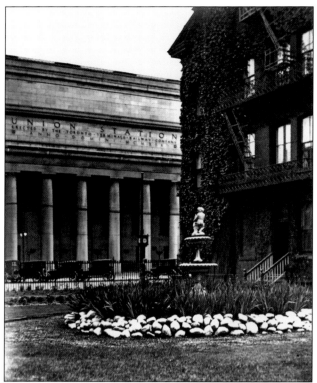

Guests at the Queen's Hotel could relax in the garden and admire Union Station for much of the 1920s. In the 1860s the Queen's had been considered the finest hotel in the city. With the Canadian Parliament occasionally located just down the street, politicians including John A. Macdonald and George Brown sat in the hotel's parlours planning for Confederation. (CTA, fonds 1244, item 3141.)

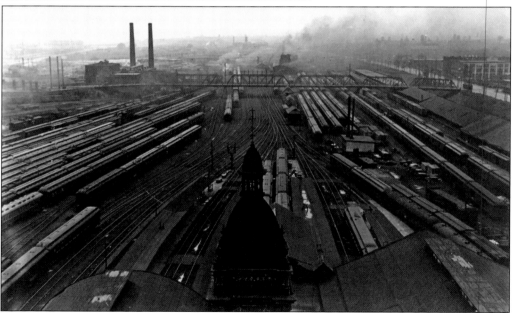

The John Street bridge intersects the top half of this 1926 view looking west from the old Union Station. The coach yards on the left are CPR, on the right Canadian National. The tall chimneys indicate the municipal works that pumped water to the Rosehill Reservoir five miles away. Today the CN Tower and the Rogers Centre occupy much of this view. (CTA, fonds 1231, item 955.)

The old CPR roundhouse is seen in 1926 looking southeast from the John Street bridge. The wooden coaling dock and water tower are on the left. By this time the facilities were obsolete for the larger and heavier steam locomotives that entered service in the 1920s, and CPR announced in December 1926 that they would be replaced by a new roundhouse. (CTA, series 372, subseries 79, item 136.)

The new John Street roundhouse was built at a higher elevation to correspond with the new Union Station grade separation. The infill began in 1927 south of the freight sheds and is seen here on April 28. The old roundhouse is on the right, and the passenger car yards are in the foreground. Today the Toronto Railway Heritage Centre occupies the centre of this view. (CTA, fonds 1231, item 75.)

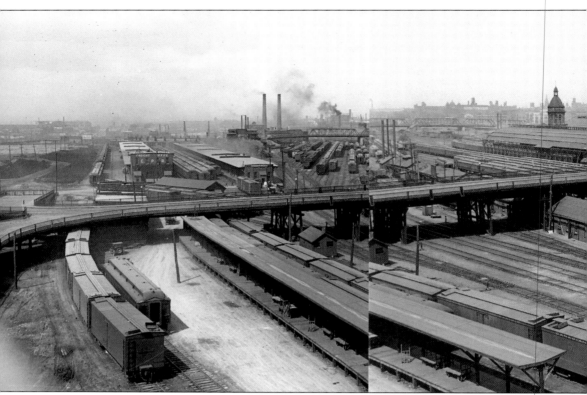

This panorama is a composite of photographs taken in June 1926 from a rooftop south of Union Station. In the top image, the bridge on the left carries York Street, behind which is the old Union Station. Underneath the station headhouse on Front Street on the west side of the bridge is a structure housing an elevator to carry mail and express from York Street down to the platforms at track level. The new Union Station is already grimy, even though it is still not open for business.

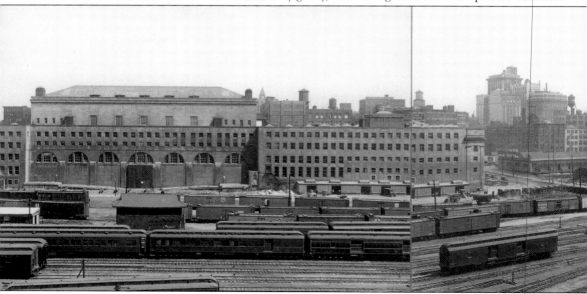

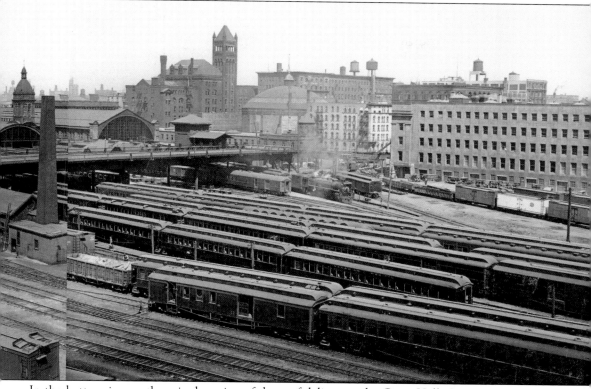

In the bottom image, the raised portion of the roof delineates the Great Hall. Construction has not yet begun on the elevated viaduct structure and the trainshed, which was not completed until 1930. When finished, track level will correspond with the bottom of the arched windows. The bridge on the right is Bay Street. Both the York and Bay bridges were replaced by the present underpasses, which opened in 1930. (CTA, fonds 1231, items 1042–1047.)

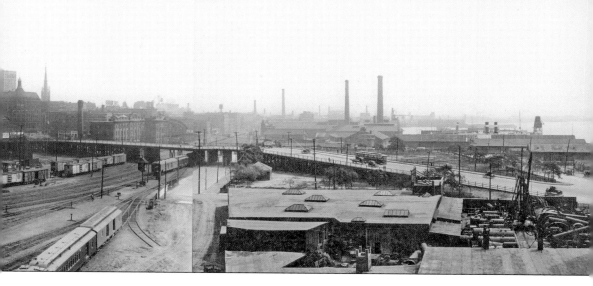

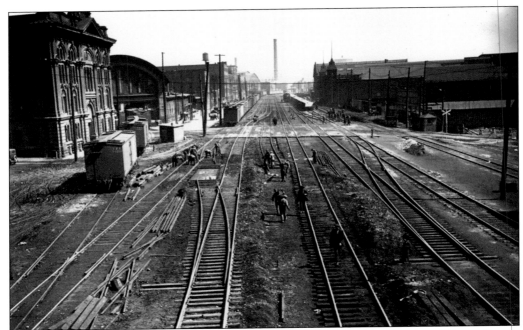

This April 1927 view is looking east from the temporary Bay Street bridge toward Yonge Street. This was Toronto's mainline rail corridor from the 1850s until 1930. The cars parked on the left are refrigerated boxcars carrying fruit from California and Florida to the fruit terminal in the old GWR passenger station with the curved roof. (CTA, fonds 1231, item 1087.)

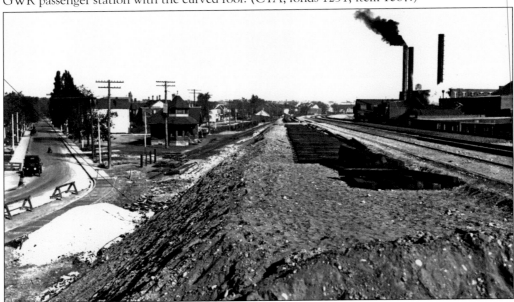

Canadian National's Riverdale Station is isolated on the old grade and rendered obsolete in this 1927 photograph looking northeast from Queen Street. Canadian National closed the station in 1932. The building was used by a variety of tenants until it was demolished in 1974. The grade separation required 2.6 million cubic yards of fill to lift the right-of-way as much as 18 feet. (CTA, fonds 1231, item 1026.)

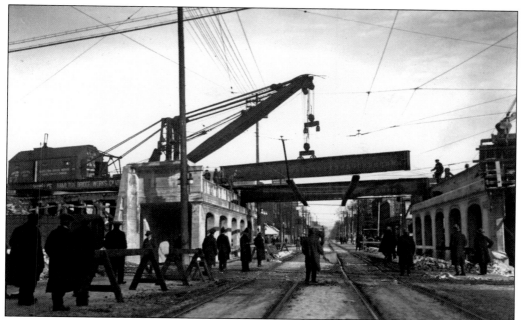

Underpasses were known as subways in the 1920s. Here is the Queen Street subway under construction in 1927 while several pedestrians and officials sidewalk superintend from below. The railway viaduct required the construction of nine such subways; the city wanted even more but the railways balked at the expense, which delayed the start of construction. (CTA, series 372, subseries 79, item 160.)

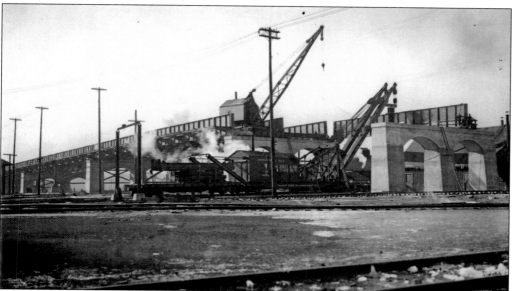

Building the viaduct also required a new bridge at Spadina Avenue, replacing a smaller structure that had been there since the beginning of the railway era. The new Canadian National locomotive and passenger car facilities required a much longer span. In 1926 steam-powered cranes of the Canadian Bridge Company lift the girders in place on the 11-span, 1426-foot bridge. (CTA, series 372, subseries 79, item 28.)

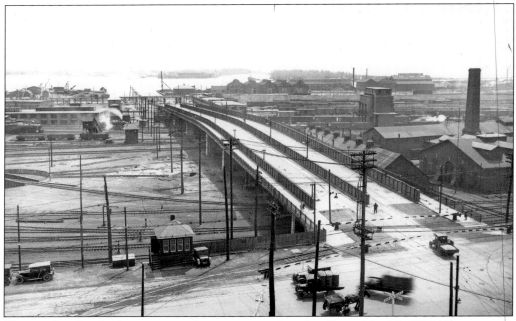

The new Spadina bridge was opened to streetcar and road traffic on May 23, 1927. The structure proved a delight to countless rail fans who had a rare vantage point from which to observe and photograph the heart of one of Canada's largest and busiest engine terminals. The building on the right is the old NRC shop that dated back to 1860 and was soon demolished. (CTA, series 71, item 4903.)

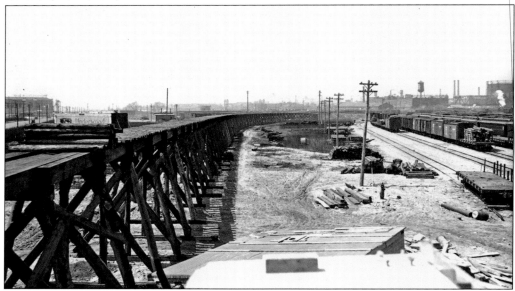

Although some parts of the grade separation required bridges and viaducts, most of it was created with infill. The Toronto Terminals Railway built wooden trestles known as falsework, the top of which corresponded to the new track elevation. This 1927 view is looking west from the Spadina bridge and shows a falsework trestle just before the track was installed. (CTA, series 372, subseries 79, item 201.)

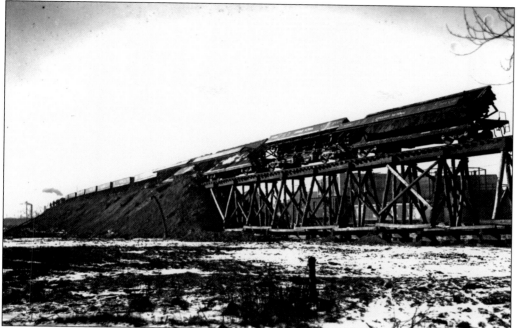

After the track was laid on top of the falsework, trains of air dump cars unloaded the fill gathered from borrow pits in Scarborough and Leaside until the trestles were buried. Day and night for five years, countless thousands of work trains repeated this process along the new three-mile railway corridor. This 1927 image was photographed between Eastern Avenue and the Don River. (CTA, series 372, subseries 79, item 179.)

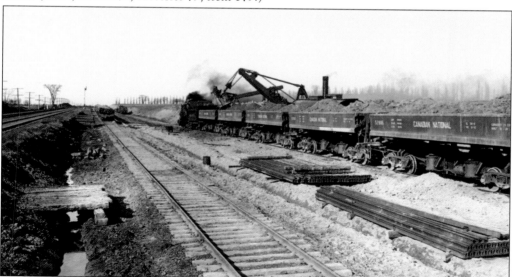

The Toronto grade separation was one of the largest urban reconstruction projects in Canadian history. The *Star Weekly* proclaimed the project as "a more spectacular thing than the pyramids only that it is laid out flat instead of being sky-pointed." The massive amount of fill came from borrow pits, such as this one on the north side of the Canadian National main line in Scarborough. (CTA, series 372, subseries 79, item 212.)

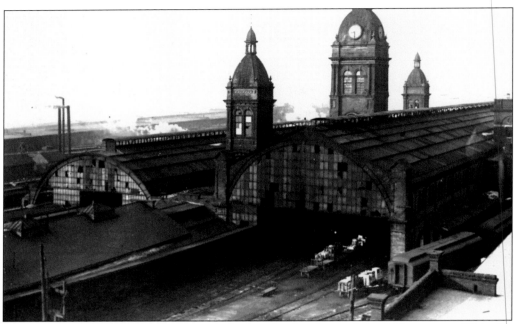

The old Union Station was considered obsolete by the dawn of the 20th century. With the uncertainty over the completion date for the new Union Station, the old station was allowed to deteriorate further through most of the 1920s. By the time this photograph was taken from the roof of the new station, authorities were not even bothering to replace broken panes of glass. (NAC, 200647.)

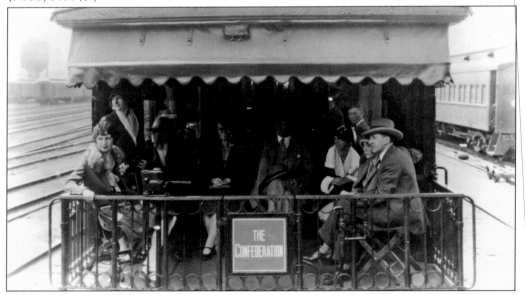

This classic view of first-class passengers lounging at the back of an observation car was posed near Canadian National's Spadina yards, whose water tower can be seen on the left. The *Confederation* was a luxurious transcontinental train between Toronto and Vancouver introduced in 1927. The train featured new sleeping cars named after the Fathers of Confederation. The train was discontinued in 1931 due to Depression austerity measures. (NAC, CZ5969.)

In the early 20th century, the railways were responsible for opening up cottage country to well-heeled Torontonians. The Muskoka, Kawartha, and Haliburton lake districts, among many others, were only a few hours by rail from Toronto, and cottages and resorts were built to take advantage of this proximity. The trains brought the rusticators to specially built wharves where steamships and motorboats delivered them to their lakeside destinations.

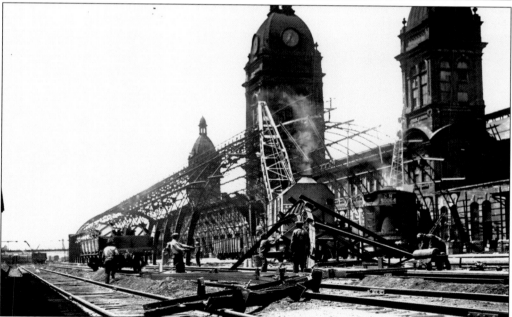

Two Canadian National steam cranes help dismantle the south train shed of the old Union Station in the early summer of 1927. Ironically one of the most recent additions to the old station had to go first to accommodate passenger and baggage platforms required by the new station since the elevated train shed would not be ready for another three years. (CTA, fonds 1257, series 1056, item 606.)

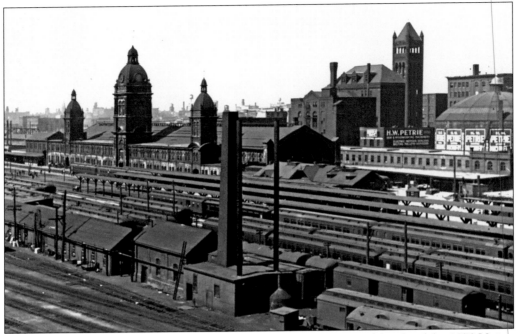

For the first time in over 30 years, Torontonians could see the original facade of the 1873 Union Station, although the harbour was now half a mile to the south. The platforms and canopies on the lower right service the new Union Station while the train shed is under construction. The structures in the foreground are part of a steam heating plant. (CTA, fonds 1231, item 866.)

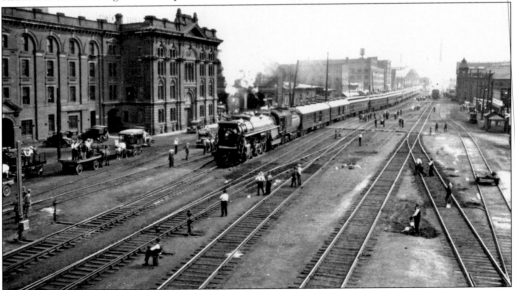

Even though construction on the new Union Station was far from complete, the official opening of the facility was coordinated with the 1927 Royal Tour of the Prince of Wales, who was visiting Canada to help celebrate the Diamond Jubilee of Confederation. On August 6, His Royal Highness's special train, hauled by Canadian National's Northern locomotive No. 6120 crosses over Yonge Street and enters the station. (NAC, PA87840.)

His Royal Highness has just stepped off his train and is being greeted on the platform by Ontario Lt.-Gov. W. D. Ross and his wife. Prince Edward was the uncle of the current monarch Queen Elizabeth II and briefly became King Edward VIII in 1936 before being forced to abdicate due to his romantic involvement with a divorced American woman who became his wife. (CTA, fonds 1244, item 999.)

The royal entourage enters the Union Station Ticket Lobby while being serenaded by a 60-voice choir. The Prince of Wales has already passed by the photographer. The young man in the uniform is Prince George, Edward's younger brother. Following behind him are Ontario Premier Howard Ferguson and British Prime Minister Stanley Baldwin, who would play a key role in pressuring Edward to abdicate in 1936. (CTA, fonds 1266, item 11128.)

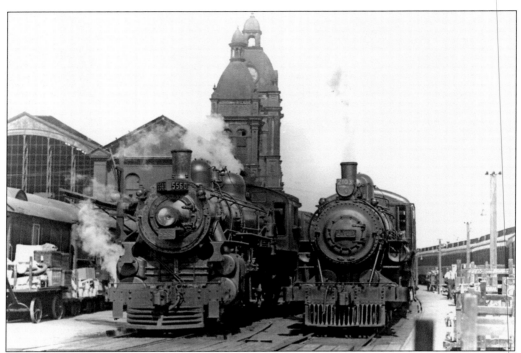

On August 10, 1927, four days after the official opening of the new Union Station, the last trains prepare to depart from the old station. A Canadian National train on the left and a CPR train on the right graphically identify the dual ownership of Union Station, which ended in 2000 when the facility was purchased by the City of Toronto and GO Transit. (Al Paterson.)

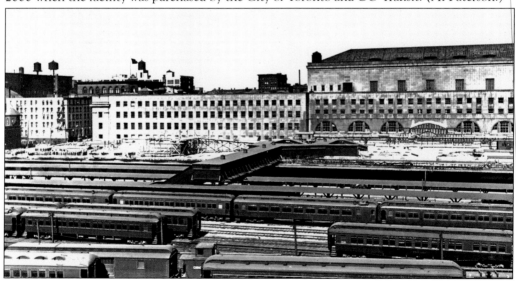

When Union Station opened in 1927, the train shed was still under construction and the platforms were located on the original grade near the old station. The temporary staircases and walkway seen here were built so passengers could access the train waiting room, now the VIA departures concourse. One newspaper reporter complained that he had to walk almost a quarter mile before boarding his train. (CTA, fonds 1231, item 865.)

Union Station's main hall is one of the most magnificent rooms in Canada but was only given the unassuming name of Ticket Lobby. Only in the 1970s did people begin calling this space the Great Hall. The vast size of Union Station can be gleaned from the fact that this room makes up less than 5 percent of the total floor space in the station complex. (CTA, fonds 1244, item 1955.)

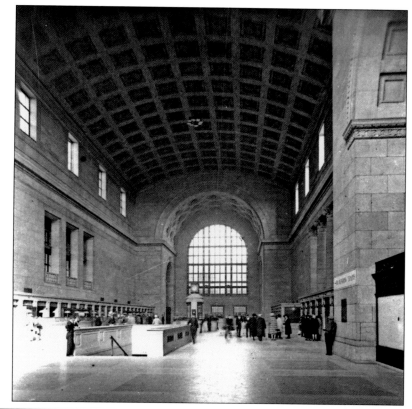

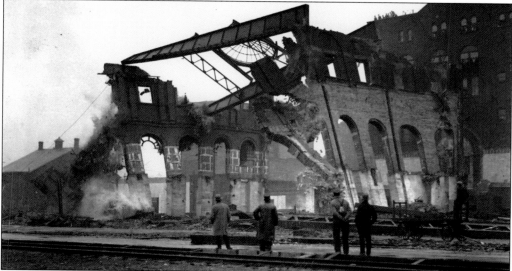

Demolishing the old Union Station proved to be more difficult than anticipated, and Canadian National provided one of its most powerful locomotives to help pull the building down in early 1928. The four gentlemen in the foreground are standing on the site of the 1873 station and observing (by today's standards, at an unsafe distance) the demolition of the waiting room built in 1895. (CTA, fonds 1244, item 14.)

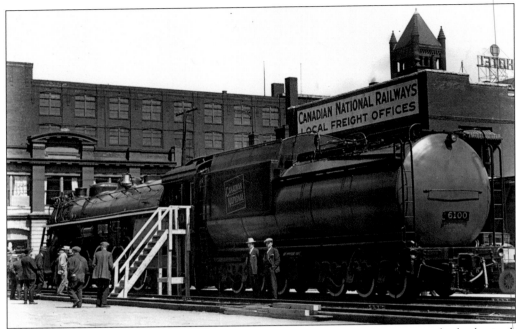

Throughout the 1920s, Canadian National upgraded the rundown equipment it had inherited. In 1927 Canadian National displayed No. 6100 at the Simcoe Street yards, the first of a new class of 4-8-4 Northern steam locomotives. Canadian National would eventually own 192 of these engines, including No. 6213, now the crown jewel of the Toronto Railway Heritage Centre. A mural depicting 6100 is in the lobby of Commerce Court. (Al Paterson.)

Union Station's Romanesque-style office building on Front Street survived until 1931 and is seen here in March 1928 after the remainder of the old station had been demolished. The hotel at the corner of Simcoe Street was also demolished in 1930 to make way for the Simcoe streetcar loop, used as a turnaround for Yonge streetcars until the subway opened in 1954. (CTA, TTC fonds, series 71, item 5687.)

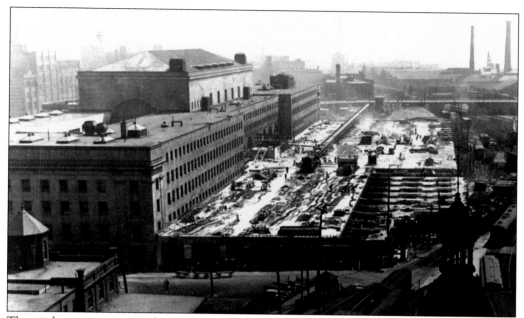

The viaduct structure was the most complicated part of the grade separation and required huge amounts of concrete, prepared in a separate plant located east of Bay Street. A movable conveyer belt mechanism then carried the mixture over to the site and deposited it where needed. The train waiting room (now the VIA concourse) is underneath the concrete pad supporting the conveyer. (CTA, series 372, subseries 79, item 244.)

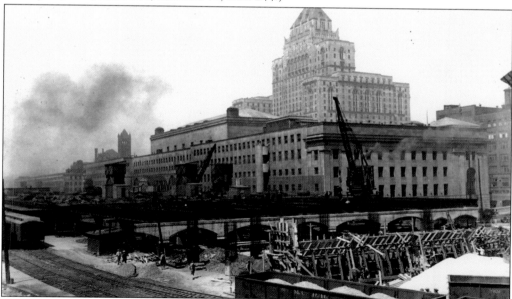

The viaduct structure extended from 90 feet west of York Street to 90 feet east of Bay Street and was integrated into both subways. The structure, seen here in May 1929, took four years to build and consisted of the train shed, the train waiting room underneath, and a basement with a complex of driveways, corridors, maintenance facilities, and train service rooms. (CTA, series 372, subseries 79, item 428.)

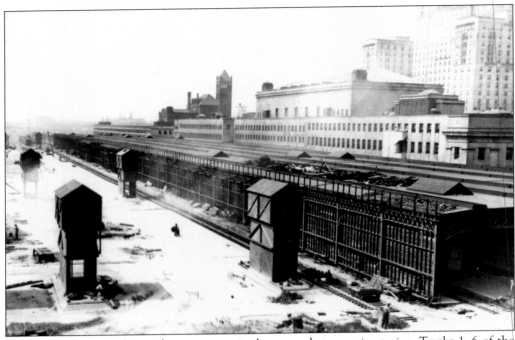

A few months later, the viaduct structure is almost ready to receive trains. Tracks 1–6 of the train shed opened in January 1930 and work continued on tracks 7–10. The structures on the left are elevator shafts used to transport baggage, express, and mail wagons from the platforms to the basement. At the time Union Station handled more baggage than any other station in North America. (CTA, fonds 1367, item 3.)

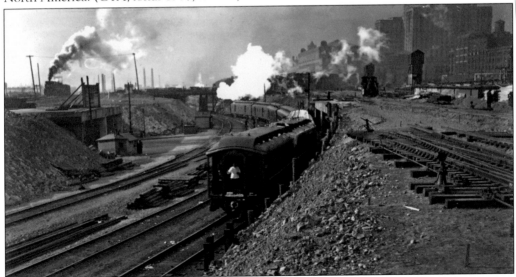

A Canadian National train crosses Yonge Street in 1929 while a white-jacketed sleeping car porter stands on the rear platform preparing for arrival at Union Station. On the upper left is a Canadian National train on the High Line, a freight bypass around the station. This photograph dramatically illustrates the difference between the old grade and the elevation required for the Union Station train shed. (CTA, series 372, subseries 79 item 490.)

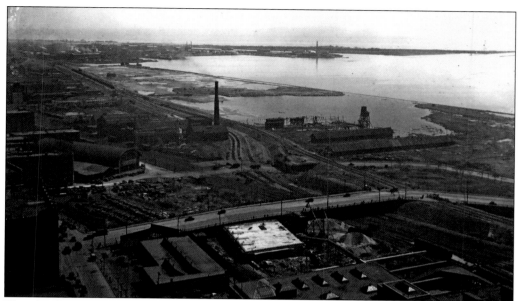

This April 1929 view was photographed from the Royal York Hotel. The temporary Bay Street bridge was in use from 1925 to 1929. The viaduct structure is still under construction on the lower right. The white square indicates the Canadian Pacific Express facility, which opened in January 1930. The massive landfill for the new railway viaduct is evident in the top half of the photograph. (CTA, fonds 1231, item 976.)

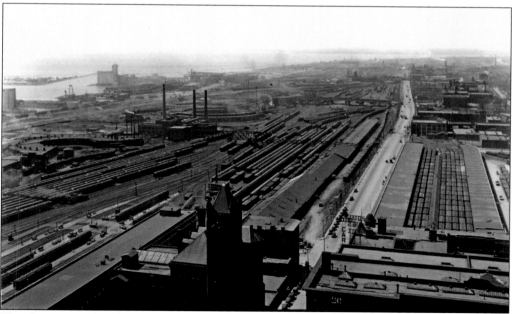

The almost completed Royal York also provided this vantage point in April 1929. On the lower left is the 1896 extension to Union Station, with the original 1873 station and train sheds already demolished to make way for the new Canadian National Express building. On the right is the congested Canadian National Simcoe Street freight facilities, now the site of the CBC Broadcast Centre. (CTA, series 379, subseries 79, item 409.)

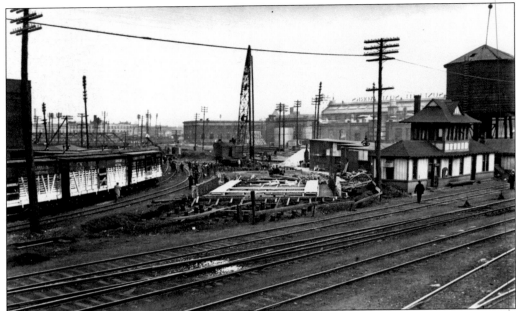

The Canadian National main line to Montreal crosses the Don River out of camera range on the right, while the Bala Subdivision curves north to Richmond Hill and North Bay. This line originally carried the TBL and later the Canadian Northern railways. The industrial complex across the river is the Sunlight Soap factory, part of the Lever Brothers soap empire. (CTA, series 372, subseries 79, item 419.)

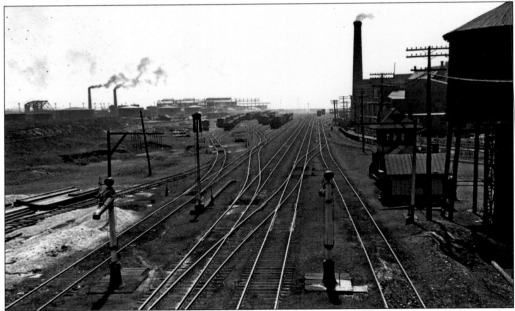

This 1926 photograph is looking west from the Don River. On the right was the GTR's Don station (not to be confused with the CPR's preserved Don station), the western terminal for the first trains between Montreal and Toronto in 1856. The track curving to the right is the former TBL. Today this is the location of GO Transit's Don Yard. (CTA, fonds 1231, item 1069.)

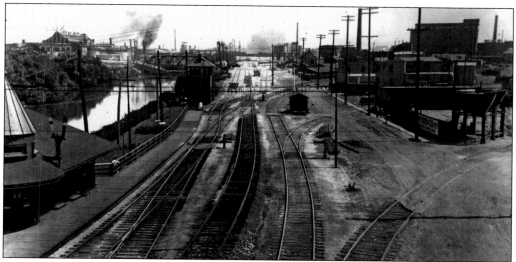

The Don station and surroundings are seen looking south from the Queen Street bridge in 1929. The tower at the end of the platform guarded the CPR tracks on the left crossing over the Canadian National. Don was closed in 1967, moved to Todmorden in 1969, and transported to Roundhouse Park in 2008 for incorporation into the Toronto Railway Heritage Centre. (CTA, series 372, subseries 79, item 451.)

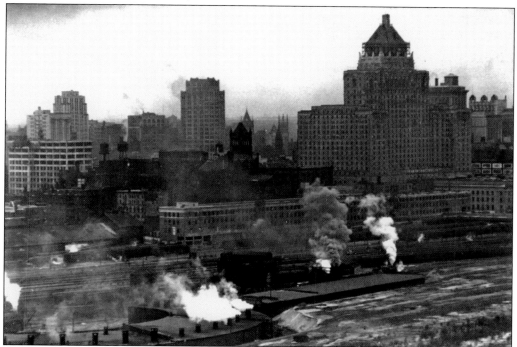

In the foreground is the fill for the new elevated John Street roundhouse while the old roundhouse continues to function on the old level. Under construction behind it is the new Canadian National Express facility that opened later in 1929. The new Royal York Hotel is nearing completion, while the tall structure to the left of it is the Toronto Star building on King Street. (CTA, fonds 1244, item 10058.)

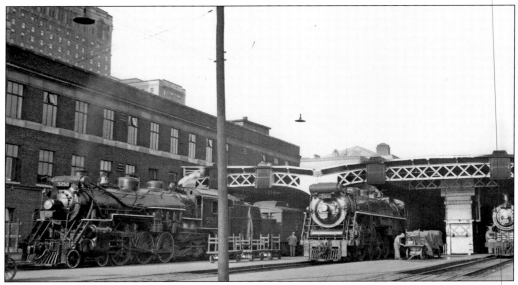

Three Canadian National passenger trains prepare to depart from Union Station around 1930. On the left is local No. 29 for Stratford; behind it is the new Canadian National Express building, built on the site of the old Union Station. In the centre is No. 17, the *Inter-City Limited* for Chicago. The silver structure under the trainshed is an elevator used to access the express facilities in the basement. (Al Paterson.)

On August 26, 1929, Torontonians saw for the first time the new technology that would eventually replace steam locomotives. Canadian National diesel-electric No. 9000 hauls the second section of the *International Limited* from Montreal onto the display track at the Canadian National Exhibition. Thirty years later, steam would disappear from mainline trains throughout Canada. (CTA, fonds 1266, item 17668.)